Japanese Art in
World Perspective

Volume 25

THE HEIBONSHA SURVEY OF JAPANESE ART

For a list of the entire series see end of book

Japanese Art in World Perspective

by TORU TERADA

translated by Thomas Guerin

New York · WEATHERHILL / HEIBONSHA · Tokyo

This book was originally published in Japanese by Heibonsha under the title *Sekai no naka no Nihon Bijutsu* in the Nihon no Bijutsu series.

A full glossary-index covering the entire series will be published when the series is complete.

First English Edition, 1976

Jointly published by John Weatherhill, Inc., 149 Madison Avenue, New York, New York 10016, with editorial offices at 7-6-13 Roppongi, Minato-ku, Tokyo 106, and Heibonsha, Tokyo. Copyright © 1966, 1976, by Heibonsha; all rights reserved. Printed in Japan.

Library of Congress Cataloging in Publication Data: Terada, Tōru, 1915– / Japanese art in world perspective. / (The Heibonsha survey of Japanese art; v. 25) / Translation of Sekai no naka no Nihon bijutsu. / 1. Art, Japanese. 2. Art, Modern—20th century—Japan. 3. Art, Japanese—Occidental influences. I. Title. II. Series. / N7355.T4613 / 709'.52 / 75-41338 / ISBN 0-8348-1007-7

Contents

Japanese Art in
World Perspective

Realism Versus Abstraction

THE BEGINNING OF
THE CONTEMPORARY
PERIOD

By way of experiment, I once asked an architect friend of mine just when the contemporary period in postwar Japanese architecture began. "Probably around 1963," he replied. We can take this opinion to mean that the period dates more or less from the time when the work of Kenzo Tange,* especially his National Indoor Stadium at Yoyogi in Tokyo (Figs. 1, 13), began to attract both national and international attention. From that time on, my friend explained, Japanese architects began to feel that they could design and build without borrowing from abroad. This is an attractive idea, but 1963 as a demarcation line is too recent a date, and it gives too narrow a meaning to the contemporary period.

Upon reconsidering the question and asking myself when the contemporary period in painting began, I think of two exhibitions that took place in the 1950s. One of them may be said to have gently opened the eyes of Japanese painters and the other to have delivered them a stunning blow. These were the Exhibition of Contemporary French Art, otherwise known as the Salon de Mai Japan Exhibition, held in 1951 at the Takashimaya Department Store in Tokyo, and the Exposition Internationale de l'Art Actuel, held in 1956 at the same store (Figs. 3, 4).

Two artists represented in the Salon de Mai particularly impressed me. One was André Minaux, whose paintings of structures composed of pipes had not yet taken on the figurative, or representational, character or the stagelike quality that they were later to display. The other was Pierre Soulages, whose almost monochrome abstract paintings in black, blue, and white or black, brown, and white reminded me of a mass of steel frames or the joists in the attic or under the floor of a magnificent wooden building (Fig. 19).

This was the first time I had heard the names of these artists and, of course, the first time I had seen any of their works. Nevertheless, I was readily able to understand the paintings and to judge that they no doubt counted among superior works even in their home country. I also felt that these works could serve Japanese painters as a starting point rather than as a goal. In a word, they were not particularly surprising to me. If there had been no war, Japanese artists would in the natural course of things have attained the level of the works hanging on the wall before me.

PAINTING DURING
THE WAR YEARS

World War II forced Japanese painters into realism. It was only natural that the authorities objected to abstract art and looked upon realism as the safest means of

* The names of all modern (post-1868) Japanese in this book are given, as in this case, in Western style (surname last); those of all premodern Japanese are given in Japanese style (surname first).

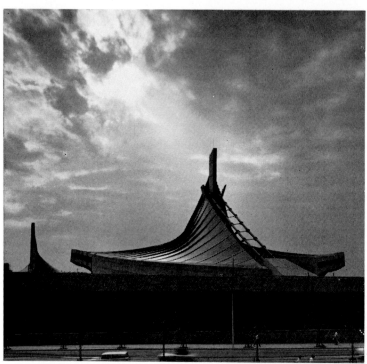

1. *Kenzo Tange Research Institute: National Indoor Stadium, Yoyogi, Tokyo. 1964.*

3 *(opposite page, left). Catalogue for 1956* ▷
Exposition Internationale de l' Art Actuel, Tokyo.

4 *(opposite page, right). Poster for 1951* ▷
Salon de Mai Japan Exhibition, Tokyo.

2. *Hiroyuki Iwamoto et al.: Detail of exterior,*
National Theatre of Japan, Tokyo. 1966.

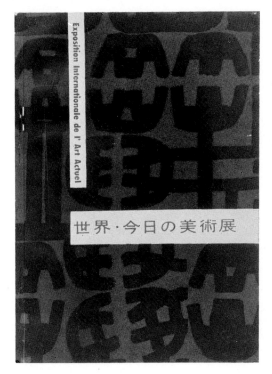

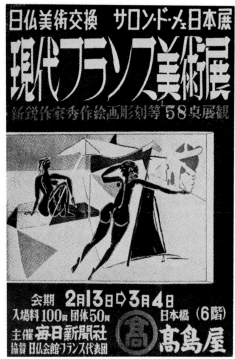

artistic expression. They feared any forms that did not come within the scope of their control, just as they feared any activity that might lead to the collapse of the tremendous destructive forces they commanded. Moreover, they needed their own terminology of persuasion in order to maintain the support and cooperation of the people.

Still, even within realism, irony could be conveyed, as in Kigen Nakagawa's *Patriotic March* (1940), a Dufy-like painting that pictures a modern Japanese soldier shaking hands with a warrior of the prehistoric Tumulus period. I know that even at the time it was produced, when political satire was expressly forbidden, it was thought to employ a suspicious art motif that sanctioned an ironic interpretation. In brief, it appeared to portray the anachronistic tendencies of the government. At the same time, although it suggested that the artist was of such character as to approve the anachronism he portrayed, it also suggested that a deep coloring of nihilism had motivated him to ignore the provisos of realism and to portray an impossible meeting of warriors from two widely separated ages. For these reasons, Nakagawa's *Patriotic March* remains clear in my memory even today, when his oil paintings, manifesting his longtime devotion to fauvism, display still another Dufy-like style, with vivid grayish brush strokes reminiscent of ink painting and yet with an overall misty appearance.

Chozaburo Inoue was quite clearly critical of the war. In his *Mule* (1941) he pictured an emaciated animal, ludicrous yet somehow mournful, with forelegs raised high and hind feet firmly planted on the ground. It was an image of determination to overcome insurmountable suffering in the last light of the setting sun. People, weapons, and even the surrounding scenery had all been obliterated. But what was it that made Inoue picture this scraggy creature? The realistic style enabled him to escape questioning by the military authori-

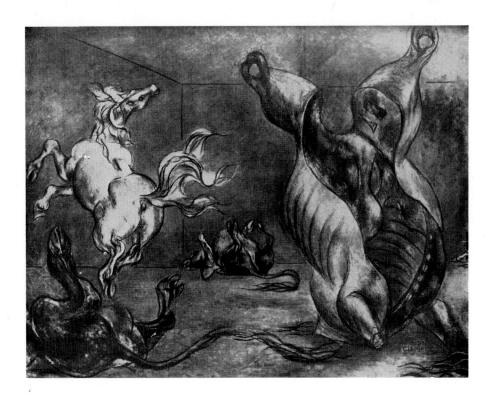

ties, but he was at the same time able to maintain his critical viewpoint and express it through a coded message to the public. The struggle of the miserable yet gallant beast symbolizes that of the common people, who must bear the sufferings of war and carry on toward the future—a future that may be only the afterglow of a sunset.

Although we did it against our will, we were forced to bear the yoke of this kind of realism during the war. The only people who had the privilege of expressing themselves unrealistically without fear of punishment were the cultural super-patriots and the ultranationalistic politicians. This is not to say, however, that we were allowed to make full use of realism, for it only meant that we were coerced into expressing ourselves in a specious form. What we entered upon as realism was in fact a form that by no means depicted the essence of our existence. Under conditions quite unlike those in periods of great political upheaval in former

times, it was extremely difficult to maintain a strict incognito under the stress of total war. Furthermore, the military authorities would hardly allow any lucid artistic expression of realism. The result was that artists for the most part degenerated into mere trivial literalism. Other artists, who did not care to portray war themes, took to painting Chinese-style landscapes.

THE LACK OF ABSTRACT PAINTING DURING THE WAR

I do not subscribe to the theory that the Japanese character fails to lend itself to dealing with things in an abstract fashion. No Japanese who continually criticizes his fellow countrymen for their abstract arguments can think this way. It is precisely the capacity for abstract thought that has enabled a number of Japanese scholars to enjoy international prestige for their academic achievements in such abstract disciplines as theoretical physics, mathe-

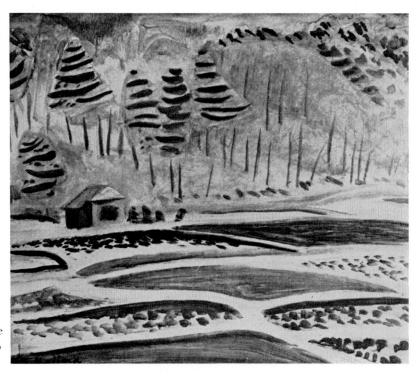

◁ 5. *Chozaburo Inoue:* Slaughter-house. *Oils; height, 181 cm.; width, 260 cm. 1936.*

6. *Zenzaburo Kojima:* Farmhouse Awaiting Spring. *Oils; height, 39.4 cm.; width, 54 cm. 1939.*

matics, and philosophy rather than in practical fields like sociology and biology. That Japanese scholars are expert primarily in theoretical realms may in fact result from the traditional poverty of Japanese society, but it nevertheless demonstrates that we have the capacity for abstract thought.

Why, then, was no abstract painting produced in Japan during World War II? One reason has already been suggested above. Another is to be found in the production of works like Seiji Chokai's Ryukyuan landscapes (Fig. 37) and his paintings of the Altar of Heaven in Peking and the historical sites of Soochow—that is, a love of surviving traditional scenes and a desire to portray them before they disappeared. This desire to preserve the old is also quite evident in the works of Zenzaburo Kojima—for example, *Farmhouse Awaiting Spring* (1939; Fig. 6) and *Rice Planting* (1943), in which the moods of traditional Japanese painting can be felt. The same motif was maintained in Kojima's

postwar paintings of scenes in the Kokubunji area on the outskirts of Tokyo.

When we saw both our internal and our external worlds being destroyed by the war, our artists, like all the rest of us, felt that the external world—or at least the images received from the external world—was more precious than our miserable internal world and that such images were what they were to transmit to posterity. It was the traditional disposition of the Japanese to sacrifice themselves for a cause, or even for the protection of some object, and for people of this disposition the external world—not the real world but the ideal world, our dream of the world in which we were living—was perhaps more beautiful than our actual human nature. Countless tales of heroism and tragedy from our past illustrate this traditional spirit of self-sacrifice.

In sharp contrast with this characteristically Japanese evaluation of the external world is the

7. *Tomoaki Hamada:* Elegy for a Recruit. *Copperplate print; height, 30.5 cm.; width, 21.5 cm. 1951.*

8. *Atsushi Kahara:* Negro Soldier. *Oils; height, 168 cm.; width,* *198 cm. 1955. Ohara Art Museum, Kurashiki, Okayama Prefecture.*

story of how the Russian painter Kandinsky became interested in abstract art. One day, as he entered his studio, he noticed that one of his paintings had fallen over sideways. He was charmed by its beauty without realizing which painting of his it was. Once he had recognized it, however, this emotion quickly evaporated.

THE JAPANESE AND NATURE

It is not that the Japanese lack the capacity for the abstract, or have too little of it, but that for the Japanese artist the natural beauty of his homeland is perhaps too great for abstract expression. Although it is true that the artists who formed the Independent Artists' Association (Dokuritsu Bijutsu Kyokai) in 1930 rejected literalist realism and advocated the predominance of the subjective over the objective through a simplification of visual images perceived, they did not separate themselves from nature. In spite of their simplification of what they depicted and the special interpretation they put upon it, they did not proceed to the disintegration or the distortion of nature.

There is, of course, a reason for this. In Japan the artist and the work have an autonomous value that takes precedence over reality. Those who hope to become painters, rather than select the vocation of painter as one of many outlets for expressing reality, first experience an awareness of some aptitude for art and then become artists, at least in embryo. Only after that do they look for something to express. This tendency is common to all spheres of art in Japan. When I hear people complain of the lack of social and ideological consciousness in the modern Japanese novel, I am invariably reminded that even in premodern times the novel

was characterized by a lack of relationship with society and humanity, and I find this quality in modern Japanese painting as well.

In this sense, Japanese painters were pure artists. The nonconformist painters who gathered to create the Nika-kai (Second Division Association) in 1914 and the members of the Japan Art Academy (Nihon Bijutsu-in), re-established earlier in the same year, were all painters of this type. The Association for the Creation of National Art (Kokuga Sosaku Kyokai) also represented this group. Aside from the workmanship apparent in his finished product, the pure artist was held responsible only for his individuality, for he considered his personality a microcosm, a small universe integrating all the essentials extracted from history. Dissociated from society, he was able, by entering his small universe, to command a full view of it. It was this detach-

ment from reality that made painting an exercise in abstraction.

ABSTRACT IMPULSE AND REALISTIC STYLE Although the style of Japanese painters was said to be realistic, their art was not that of true realists, for it bore no relation to the complex and multifaceted reality that generally goes by that name. Instead, they dealt with an abstracted reality expressly quarried out, so to speak, for the purpose of painting, and what they achieved was something quite different from realism. Since they were not true realists, the impulse toward abstraction was weak, and because of this weakness, coupled with the bent toward realism imposed on them during World War II, the development of genuine abstraction could be seen in the works of only a few Japanese painters.

9. *Tai Kambara:* Verlaine's Poem "Woman and Cat."
Watercolor. 1923.

10. *Tomoyoshi Murayama:* A Jewish Girl. *Collage;
height, 40 cm.; width, 26.5 cm. 1922.*

The general public, on the other hand, was ready to receive abstract art, and it was this situation among Japanese art lovers of the time that made possible the Salon de Mai exhibition in 1951. There is no other way to explain the sense of expectation and yearning with which we then looked toward genuine abstract art—or the absence of repugnance or ridicule that might have stemmed from lack of understanding. The fact is that by the mid-1920s the Japanese audience had already become familiar with the rejection of realism by the futurists, the cubists, and the dadaists, and even before 1920 a thoroughly cubist style was displayed by Tetsugoro Yorozu in his *Leaning Woman*—a style that he had arrived at independently. The fundamental difference between abstract art and these non-realistic trends must not be overlooked, of course, but our feeling for contemporary art, through such preparation, had no doubt grown remarkably in spite of having been suppressed during the war, until at last we saw and welcomed the nonrealistic works presented at the Japan exhibition of the Salon de Mai in 1951—works by Soulages, Schneider, Poliakoff, Hartung, Tal Coat, Ravel, Singier, and others.

NONDECORATIVE VER-
SUS DECORATIVE

The success of this exhibition was not entirely ascribable to the readiness on the part of the Japanese audience but also, and perhaps to a greater degree, to the works themselves. Something in the paintings

11. Takeo Yamaguchi: Split. *Oils; height, 182.5 cm.; width, 182 cm. 1965. Ohara Art Museum, Kurashiki, Okayama Prefecture.*

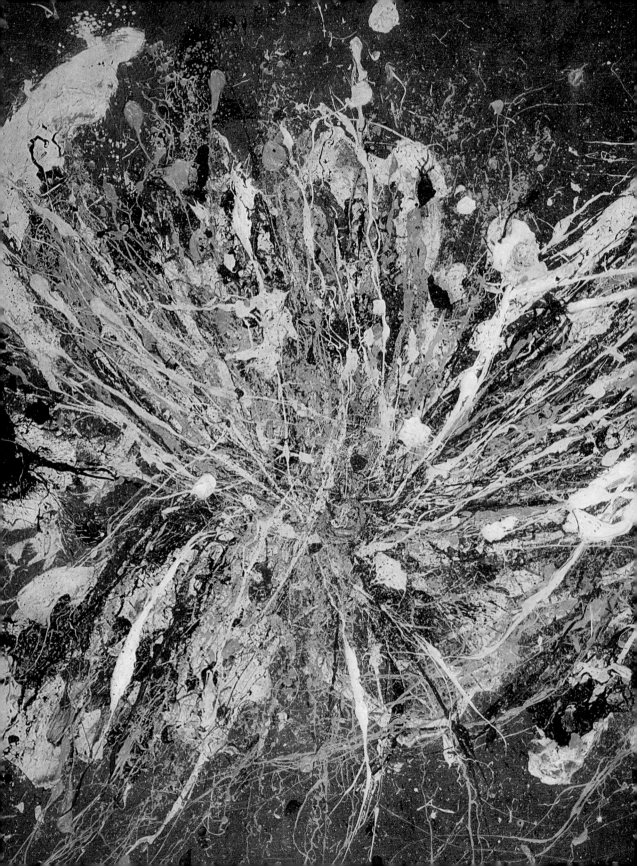

12. *Toshimitsu Imai:* Eclipse. *Oils; height, 129.5 cm.; width, 161.5 cm. 1963.*

13 *(overleaf). Kenzo Tange Research Insti-* ▷ *tute: National Indoor Stadium, Yoyogi, Tokyo. 1964.*

14 *(second overleaf). Toshinobu Onosato:* ▷ Circle. *Oils; height, 130 cm.; width, 162 cm. 1964.*

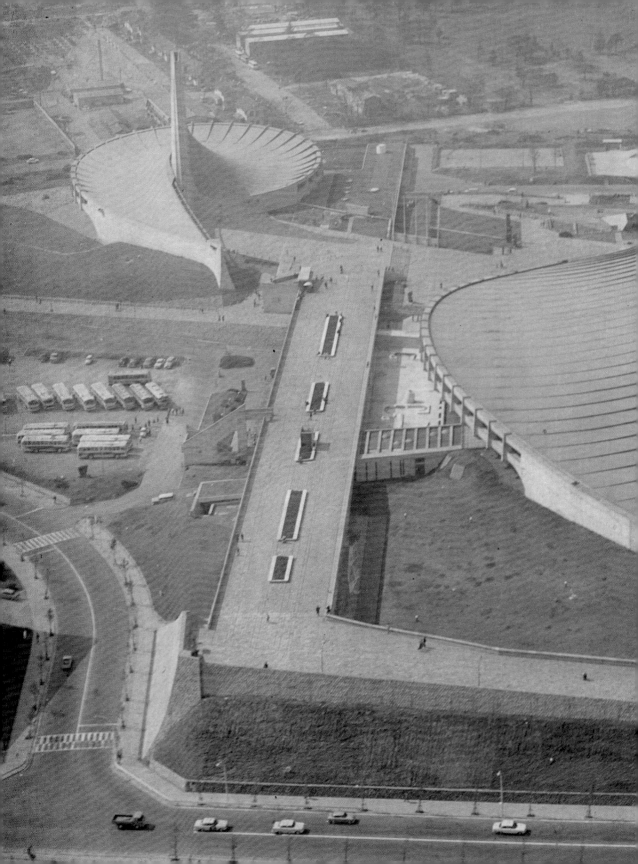

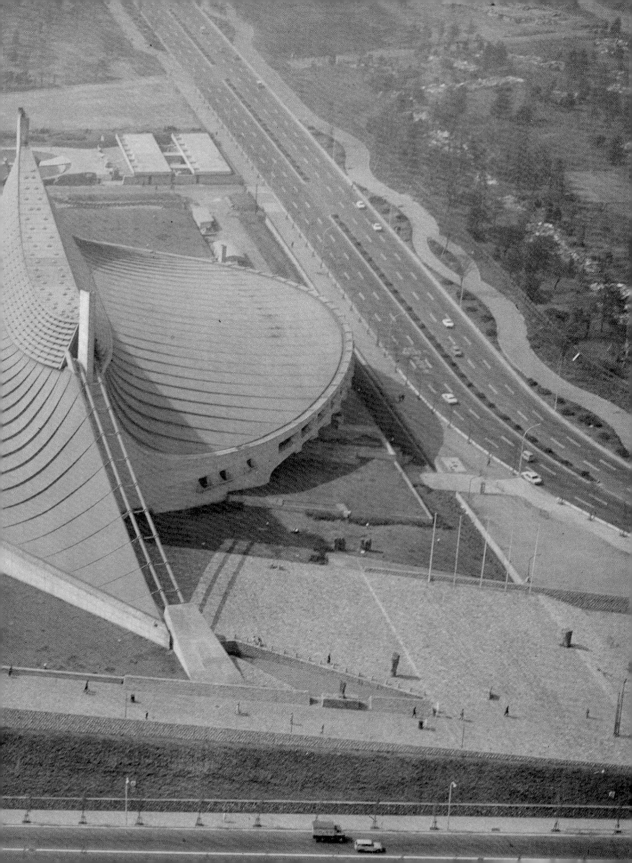

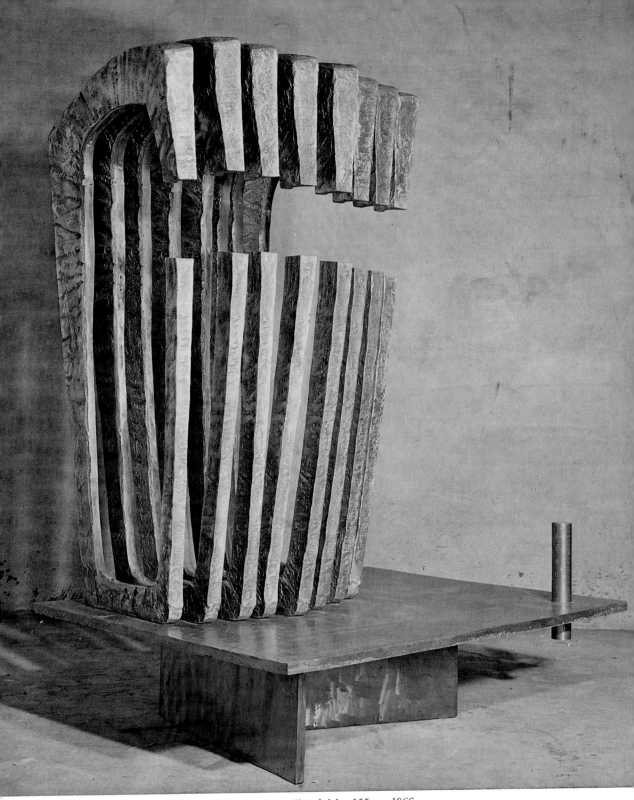

15. Takeyoshi Inoue: Question No. 180-66. *Aluminum alloy; height, 155 cm. 1966.*

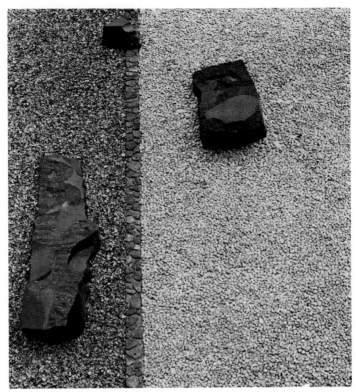

16. *Masayuki Nagare: detail of roof garden, Tenri Building, Tenri, Nara Prefecture. 1962. An example of a contemporary rock garden.*

disarmed us and put us at ease. This sense of relaxation was particularly strong in the case of Soulages, and what broke down our defenses was the nondecorative character of his paintings. To be sure, the nondecorative quality was suggested by the very paucity of color—black, blue, and white or black, brown, and white—but this was not the major cause of the effect his paintings had on us. It was the nondescriptive, nonrepresentational style of the paintings, aided by the small number of colors used, that allowed us to see them as nondecorative. Why this should be true is not difficult to explain. No matter how much it may be embellished by theory, representational art cannot escape its fundamental characteristic of being a copy of a part of reality—or simply an addition

to an already existing object. In other words, it falls into the same category as portrait painting, which, by definition, presupposes a model. No matter how well it is molded by the artist's hands as his own creation or how much value he attaches to it, a portrait is a copy. Why, then, do we make copies of what already exists? Why do we make imitations of reality? The only answer seems to be "to decorate." If a descriptive work of art were to be created in search of truth and for the purpose of recording the results of that search, there would hardly be any special reason for the artist to complete it. (This may be the reason that Leonardo da Vinci left so many of his works unfinished.) But in the case of the artist who looks forward to completing his work, it seems that what he is about to

17. Hasegawa Tohaku (1539–1610): detail from Pine Grove, *a pair of sixfold screens. Ink on paper; dimensions of each screen: height, 156 cm.; width, 364 cm. Late sixteenth century. Tokyo National Museum. An example of nature depicted in monochrome ink.*

achieve is the goal of decoration, as the Japanese realist painter Ryusei Kishida effectively pointed out.

There are various places and purposes for such decoration. For example, a decorative painting may be placed where the copied model can also be seen, thereby enhancing the value of the model in the viewer's eyes. Or it may be placed where the original subject cannot be seen, so that the value of the subject can be ascertained from time to time without the necessity of imagining how it looks. Whatever the purpose may be, one cannot deny that realistic copies of real objects are made either to adorn reality or to show its irreplaceable value. Or, to put it in another way, they are made as redundancies.

CHAPTER TWO

Abstract Painting

THE ESTABLISHMENT OF THE SUPRANATIONAL CONCEPT

The nondecorative character of Soulages's work bespeaks his lack of any intention of forcing us to recognize the existence of a valuable model that he chose to portray. For example, his work does not make us think of France. It is often remarked that his pictures convey the idea of sturdy building materials—pillars, girders, and crossbeams—and that our subconscious memories of such images are brought back to life through the vigor of this farmer from southern France. This may well be so, but the image of France itself is absent. On the contrary, the paintings have a supranational, universal force, and the building materials embodied in them are not those of any individual country. That is to say, the Romanesque arch of southern France and the peasant strength that, in the terminology of the Cézanne school, "realizes" our subconscious memory of it no longer belong to one country but have become a universal property.

Some years ago, when France realized that it could maintain its honor and its traditions only as a nation within an alliance of nations, I advocated a world vision that would replace the older concepts of "France" and "Europe." Perhaps the formulation of that proposal was not quite adequate. I should have given a more positive meaning to the notion of "world," not as something to have to yield to but as a new sphere of activity to be dis-covered when France freed itself from itself. What I am trying to do now is to see things from this viewpoint. It is this world perspective that I believe underlies the work of Soulages—a concept completely different from that of living globally through the glory of France. But even though an artist like Soulages may choose to make the whole world his dwelling place, it must be remembered that the choice could not be made without abandoning the point of view, represented by Valéry and others, that placed the supreme value on France. And this means the renunciation of the concept of the small Mediterranean universe as well. Thus we can assume that one of the characteristics of contemporary painting is the artist's adoption of a cosmopolitan rather than a national viewpoint.

MINAUX AND BUFFET

In 1951 André Minaux attracted me with his black-and-yellow still life of a pipe and a cup—a painting that displayed a specially flavored and highly effective technique in the painstaking use of a palette knife to spread the thick paint in an extremely stylized composition. But he seemed to have become somewhat foreign when his much more concrete works like *Still Life with Chair* and *Fish Market* were shown in 1951 at the Yomiuri Independent and in 1952 at the First Japan International Art Exhibition. These pictures seemed to be imbued with the intent to overwhelm the view-

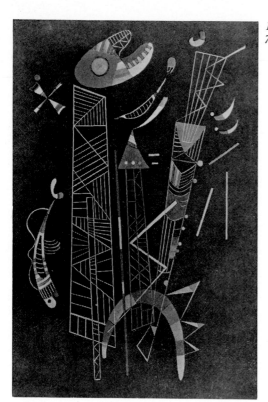

18. *Wassily Kandinsky:* Lighthearted Composition. *Oils; height, 72 cm.; width, 49 cm. 1940.*

19. *Pierre Soulages: untitled work. Oils; height, 130 cm.; width, 97 cm. 1960.*

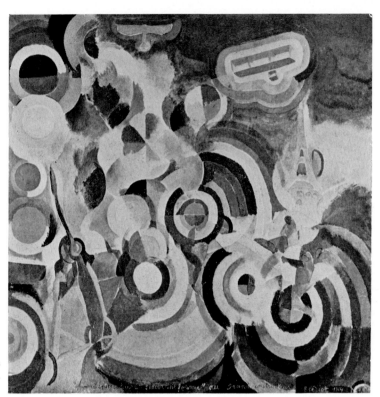

20. *Robert Delaunay:* Homage to Blériot. *Oils; height, 250 cm.; width, 250 cm. 1914. Private collection, Paris.*

er with the quantity of paint that had been used in them. And he seemed to have become even more foreign in his picture of a Pyrenean woman in a vermilion and orange costume—a work that was shown several years later. The local color and the strong national character that permeated it disappointed and discouraged us. In fact, Minaux's popularity declined in Japan from that time onward.

At a somewhat later date the works of Bernard Buffet were introduced to Japan and for a while had the greatest of popularity there. Personally, I find myself unable to admire this kind of work because of its cold, sickly, and harsh effect. Even from a theoretical point of view, that anemic color and that surface of lines resembling a bunch of slightly staggered black needles—like the pictures of Yume-ji Takehisa—express nothing more than some obscure concept or pathos, or at best a pictorial translation of an awareness of emptiness that can embrace neither thought nor feeling. In this respect, his work never satisfies us. But it is possible to interpret it as an expression of his intention that it may paradoxically appeal to contemporary man. In fact, works of his like *Barracks,* in which the positive use of his intentional disengagement is discernible and so much message is conveyed by the void felt in the subject, are not disagreeable at all. His *Eiffel Tower,* too, captures the contemporary world by representing the nothingness that is a great barrier to contemporary man—the gaunt, gigantic skeleton, thin, full of gaps, and yet tenaciously hampering in the misty semiabstract space in which contemporary man is destined to live.

THE SUPRANATIONAL CHARACTER OF CONTEMPORARY PAINTING

Looking at the history of painting from the baroque period on, we can see that supranationality could hardly have been expected to be capable of giving birth to powerful art, but it has now come to be acknowledged as the quality that has bestowed on painting after World War II the greatest persuasive power and relevance for contemporary man. It may seem strange to make this point by citing only the work of Soulages and his inverse image Buffet. But the absence of nation-centered characteristics in such other modern painters as Kandinsky, Mondrian, Klee, and Delaunay (Fig. 20) is also well known. Even where there is some national identity, there is at least a mixture of nationalities, as symbolized by the marriage of the Delaunays, and any national characteristics that might be discernible in their work are certainly unintentional and no more than incidental aspects.

Soulages expresses the essence of the universality of contemporary painting when he says: "Because painting is an adventure of stepping into the world, it signifies the world. And because it is a synthesis, it signifies the world in its totality. Again, because it is a poetic experience, it signifies the world through a process of transformation. No matter what coordinates are used, this metaphor cannot be arbitrarily penetrated or explained by anyone who tries to find an equivalent for it."

The following statement by Soulages also deserves careful attention. "Whereas figurative painting introduces relations between particular elements of the real world, nonfigurative painting introduces the relation of totality to totality.

22. Masanari Murai: Tobias and the Angel. *Oils; height, 118 cm.; width, 91 cm. 1950. Kanagawa Prefectural Museum of Modern Art, Kamakura.*

Whether for the viewer or for the artist, the world is no longer merely looked at. It is lived. . . . Therefore this kind of painting, which lacks a representational function, is surrounded by the world and relies on the world for its meaning."

Another view of abstraction has been expressed by Ben Nicholson, who attracted us at the First Japan International Art Exhibition with his still life of a fish—a work of flattened cubism, so to speak, that gave the impression of cold, serene poetry—and his geometrical white reliefs that fell somewhere between painting and sculpture. One of the primary differences between representational and abstract art, Nicholson points out, is that the former can, for example, take the viewer to Greece by reproducing the blue sky and sea, olive trees, and marble pillars. But one has to concentrate on the picture in order to participate in the journey, whereas an abstract painting can express the dynamic quality of Greece itself through its free use of color and form.

Perhaps our easy acceptance of abstract art in 1951 was grounded in the fact that we could appreciate the supranational outlook of the artists, even though this may have been only a subconscious reaction.

JAPANESE ABSTRACTION The foregoing is somewhat removed from reality, however, for it is not correct to assume that there had been no abstract painting in Japan before 1951. The truth is that even before the Japan exhibition of the Salon de Mai some of us were troubled by the exclusively sensuous and unstructured "abstract" works of our painters. I can confirm this from an article that I wrote for a mag-

23. Tatsuoki Nambata: Rhythm of Lines. *Oils; height, 80.3 cm.; width, 100 cm. 1958.*

azine early in 1950, but it is difficult to remember now just whose work I was thinking about in particular. Saburo Hasegawa, Masanari Murai, Masaki Suematsu, Minoru Kawabata, Hajime Minami-oji—the names of those who had already shown some nonfigurative works are not hard to remember. And the works, too, I can remember: Saburo Hasegawa's excellent abstraction *Butterfly Tracks* and another work of his, resembling a construction of colored paper, with rectangles showing black wood grain placed here and there; the reds of Minoru Kawabata (Fig. 24) and Hajime Minami-oji; the intricately blended colors of Masaki Suematsu's geometrical patterns; and others. I am not at all sure, however, whether these representative abstract works were the products of the years be-

tween 1945 and 1950. At that time the trend of nonfigurative painting was still in the embryonic stage and had not yet given rise to any monumental works, so that it is hard now to recall specific paintings. The general impression of mediocrity that remains in my memory may in fact reflect the actual state of abstract art in Japan at that time.

Perhaps the psychological situation was such that soon after World War II we were exposed to nonfigurative paintings that represented nothing more than the rampancy of the senses expressed in undisciplined color and without definite form. Not that we had any attachment to realism or that we wanted to be tied down to reality again, but that in comparison with the intense, heated, and heavy feelings that those of us who had lived through the

24. *Minoru Kawabata:* Rhythmic Black. *Oils; height, 130 cm.; width, 260 cm. 1961. Kanagawa Prefectural Museum of Modern Art, Kamakura.*

war had toward reality itself, these thin, superficial paintings, with their patchwork veneer of abstraction, did not carry much conviction. When we recognize that the work from this period that left the strongest impression on the memory was Motomu Saito's picture of a tall, thin nude sitting amid a pile of charcoal briquettes against a scarlet background, I think we can guess both the nature of our expectations toward painting and the nature of our dissatisfaction with it. Perhaps we hoped that this unreal figure (or perhaps realistic when considered subjectively, but nonexistent in actuality as such) would bring convergence and order to our diffused feeling of living in an intense time—a dark and chaotic period that still held a germ of hope for the future.

Art critics like Marcel Brillon see abstract painting as a reaction to cubism. They claim that the intellectual analysis and synthesis aimed at in cubism is denied by abstract art and even maintain that there has been a certain restoration of sensuousness in abstract painting. This is a natural argument consistent with the view that abstract art is to be considered the direct expression of the artist's life experience, as is indicated in the above-noted comments by Soulages and Nicholson as well as in comments by Hartung and other advocates of abstractionism.

But Japanese abstract painting around 1950 was excessively sensuous (I remember answering a questionnaire in which I called it an eyesore), and it brought no order to our own sensory experience.

25. Kyu Ei: untitled work. Oils; height, 145 cm.; width, 125 cm. 1959.

26. Kinuko Emi: untitled work. Oils; height, 162.2 cm.; width, 112.2 cm. 1961.

On the contrary, it only served to make that experience incoherent, incomprehensible, and more and more sensuous.

Thus we had to wait for six years after World War II before we saw for the first time genuine abstract art that was an ordered expression of world experience and of the world itself. This was the reason for our immediate acceptance of Soulages and his fellows, for our recognition in them of the dawn of contemporary painting, and for our awareness of having found a starting point for Japanese abstract art.

CHAPTER THREE

Art Informel

THE NATURE OF
ART INFORMEL
Here let us consider the world outlook of Hans Hartung, another abstract artist whose work was represented in the Salon de Mai exhibition. Let me borrow his own words: "Our experience is made up of all the things that we have lived. The perception of cold, heat, pain, all the internal workings of my body—these are the very things that allow me to approach cognition of the world. When we come into the world as babies, we fear having to live in reality, and we cry. This is the way we come to know the world. The things we feel with our bodies are much more powerful than the reds and blues that we see around us. We, as artists, must express all of that. The real problem is different, however, because the simple reduction of experience to an image does not make us aware of either the object or the world. I do not do away with the act of seeing—quite the reverse —but vision is not the only manner of cognition."

This important world view, crystallized here, suddenly burst brilliantly before us in the work of abstract artists in the postwar period. But the "world" here was understood as the undisrupted whole, or its mental image, that was formed almost as a reflex in reaction to the denial of the individual phenomena that had unfolded before the artist's eyes—his joy, his encouragement, and his problems —and of the practical conditions that governed him. It was the noumenon from which these various specific phenomena and concrete conditions

were deduced. Moreover, it was the image shared commonly by all painters as a requisite to which they had to return and in which they took root in order to begin their work.

But this world view immediately underwent a radical change. Among artists, the world that each believed he had grasped as a unified whole was quickly torn asunder, and *art informel*—art not relying on form—was born. The fact may be that this phenomenon had slowly begun to take shape before 1940, not attracting anyone's attention, and then suddenly burst upon the world of artistic expression. Either the phenomenon spread throughout the world or else what was already there came to be recognized all over the world, and without doubt its supranational character was made explicit. On the other hand, artists could not hold the whole world within themselves, and, rather than participate in the various self-evolving aspects of the world, they actually split and diffused themselves all over.

If I merely list the names of these artists, those who can remember even a little of their work will understand what I am trying to say: Jean Fautrier, Jean Dubuffet, Georges Mathieu, Jean-Paul Riopelle, Zao Wou-ki, Mark Tobey, Jackson Pollock, and Franz Kline. Just like the postimpressionists, these men eventually all developed highly individual styles. What little they had in common was that they had already been unable to come to grips with nature or with the world. Instead of each

artist's being a microcosm, they showed themselves to be mere fragments of the cosmos thrown out into space.

It is not my intention to cite Pablo Picasso as a pioneer of *art informel*. But when one looks back over the history of Picasso's work, one of the first things that come to attention is that for him there was society but no nature. His landscapes are extremely formalized, like stage scenery, and I dare say that, if in anything, it is in the men and women factory workers shopping at a shabby market on the outskirts of a town, or in the lonely man with a small beer mug, that we can sense a feeling of nature. From his *Harlequin* in 1923 to his paintings on themes from Velázquez's *Las Meninas* in the late 1950s, Picasso painted things that had already been made for people to see, so that, in a word, they could see things they already saw. He painted anything that fell into this category. Let it be a bull, its head, or its skull, as far as Picasso was con-

cerned, it was more of the world of man than of nature. Perhaps through his genius of repeatedly painting anything at all, he was able to hold out against the danger of disintegration of form i n-plicit in *art informel*. In him, the image of a unified world had already been lost.

An artist's paintings are a crystallization of his inner world. The denser the crystallization is, the more strongly are we made aware of the existence of such a world, and the deeper the meaning hidden in the crystal, the more we feel it to be a completely unfolded world that can well rival the real world. This is true even in the case of an artist like Wols, who died young and left only a few small works. Wols was one of those artists who give close, untiring attention to the minutest details of creation, and for this reason he has quickly become an artist of fond memory among us. He was certainly a pre-*informel* artist. Whether he attempted to answer the call of Tapié or not, he went even beyond

27. *Jean Fautrier:* Nude. *Oils; height, 89 cm.; width, 146 cm. 1960.*

28. *Sam Francis:* Intersection. *Oils. 1960.*

Picasso in maintaining a link with the past. But it is difficult to deny that, except for Mark Tobey, the artists I listed earlier in this discussion are in a limbo with neither antecedents nor successors and that their works, like misinterpretations of Zen Buddhism, concentrate on effect rather than on the reflection of the artist's own existence.

Sam Francis's *White,* in which an ivorylike white is covered with the same white to produce thick shadows of white, undoubtedly possesses a quiet exquisiteness. But this painting is linked at best to the inner world of the artist, and because it has no connection with any existence in reality or with the theme of any other picture, we can say that it is a kind of work whose disappearance would leave no trace of something that had an existence. And that inner world of Francis's is such that only when he literally believes that the sole meaning of painting lies in the very act of spreading paint—only then does his inner life too have some meaning. Of

his more recent *Blue Balls* series, in which ultramarine balloons or bubbles float on a white paper surface and seem to be trying to sail up and away, we can say figuratively that these paintings are the work of an artist who no longer takes any interest in seeing other artists' paintings.

For me, even the elaborateness, honesty, and grace of Mark Tobey are only on the surface of the canvas, and it seems as if the picture were cut off from everything else, surrounded by nothing. In this connection, *art informel,* in that it does not interpret the world and express it but is itself simply an existence in reality, may be called a self-acknowledgment of being merely one more existence among many. Tobey's "white writing" is said to be a technique he borrowed from Oriental ideographic writing. (The Japanese language uses the same word for "to write" and "to paint.") This "white writing" could be regarded as an attempt to transfer the "writing" aspect of calligraphy to

29. *Mark Tobey:* Towards the White. *Distemper; height, 114 cm.; width, 72.4 cm. 1957.*

30 (opposite page, left). Toshimitsu Imai: untitled work. Oils; height, ▷ 130 cm.; width, 89 cm. 1962.

31 (opposite page, right). Kumi Sugai: Blue. Oils; height, 162 cm.; ▷ width, 130 cm. 1962.

painting, but as long as a picture is not letters of the alphabet, "white writing" does nothing more than represent the existence of an artist who has regressed to being a craftsman. Or perhaps it can be said merely to display the carrying out of a plan on the surface of the canvas. Nevertheless, Tobey's nonfigurative "writing" is purported to express meaning without form as *signifiant de l'informel*. In the final analysis it is a kind of action painting, although quiet and tender.

Jean Fautrier (Fig. 27), when he proclaimed the birth of *art autre,* showed his distaste for oil painting, which he felt had exhausted all possible techniques over its four-hundred-year history. What he was trying to do was to reject the world and to declare the singular existence of his own action. He had to deny the dualism involved in painting—of man and nature, of subject and object, of topic and method, and of means and end—whether by painting he meant the operation of clotting his canvas with colored, hardened whitewash or the operation of covering it with some pigment thinner than oils. No matter if Fautrier's paintings seem to renounce all allegations, and no matter if he is truly the humble person he is reputed to be, we cannot find in him the quality that puts the viewer's mind at rest by conveying a feeling of coexistence with the world through a world consciousness—a feeling that is found in the works of Soulages, Nicholson, and Poliakoff.

ABSTRACTION VERSUS ART INFORMEL

What do I mean when I speak of abstract art and *art informel* as two different things? Am I not merely making a distinction where in fact no distinction exists? It may

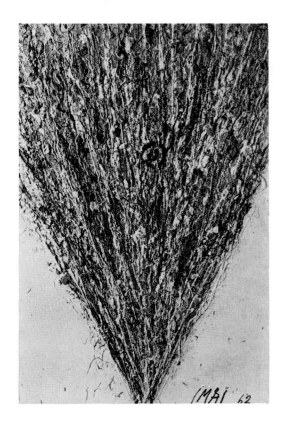

seem so to some, but actually, in addition to the various conditions and characteristics already noted, there is the major difference that in any work of abstract art, when we look at it carefully, we find that figures in the composition are distinct from and independent of one another.

Even in Kandinsky's work the various weird, multicolored elements, although they are hard to define in words, are all independent, and for that very reason the whole canvas is able to produce an emotional, symphonic effect beyond the scope of pictorial art. Or, for that matter, when Delaunay aligns his figures as though one were an echo or a resonance of the other—that is, in such a way that if the latter figure were not present, neither would the former be—clearly he is not assuming a monistic viewpoint regarding each of his figures. His attitude therefore differs completely from the totalistic attitude of the *informel* artists. For Kandinsky and Delaunay, as for other abstract artists, no matter how many colors and shapes they use (as *informel* artists also do), the overall harmonious effect is more important than the differences among the elements. To generalize, we can say that the abstract artist arrives at the figures for his composition by analysis, so that these various elements, when put together, will produce an effect he already has in mind. The attitude of the *informel* artist, however, is quite different. He arbitrarily and indiscriminately commands the structuring elements of the picture until a semiconscious and accidental but nevertheless satisfactory effect is produced. The result is a picture with entangled colors and shapes that serve only to cancel one another's effect.

In abstract painting, the artist has to compose

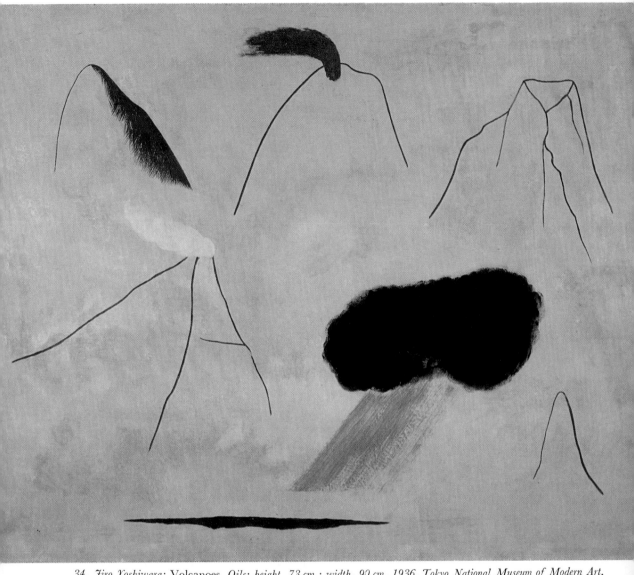

34. *Jiro Yoshiwara:* Volcanoes. *Oils; height, 73 cm.; width, 90 cm. 1936. Tokyo National Museum of Modern Art.*

◁ *32 (opposite page, top).* Shigeo Okabe: Work U·Z. *Oils; height, 248.5 cm.; width, 333.3 cm. 1965.*

◁ *33 (opposite page, bottom).* Hisao Domoto: Dissolution of a Continuum. *Aluminum. 1954.*

35. *Shunsuke Matsumoto: Landscape in Browns. Oils; height, 50 cm.; width, 131 cm. 1940.*

36. *Toshiyuki Hasega-
wa: Zoo Scene. Oils;
height, 45 cm.; width,
53 cm. Undated. Bridge-
stone Art Museum, Tokyo.*

*37. Seiji Chokai: Oki-
nawan Landscape.
Oils; height, 45.5 cm.;
width, 65 cm. 1940.*

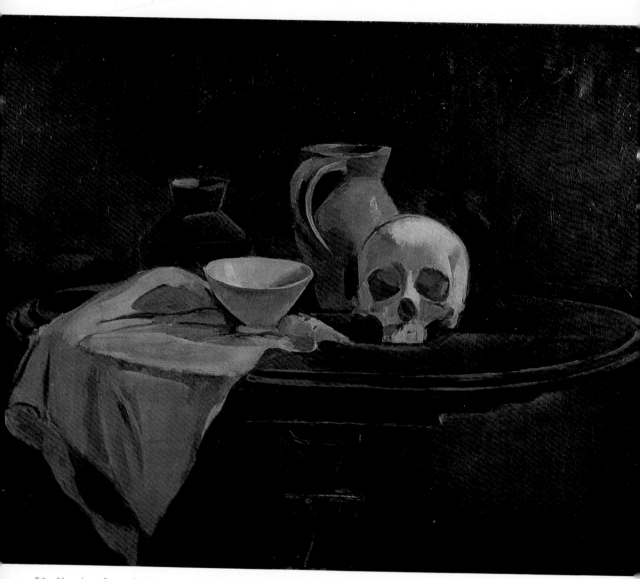

38. Chozaburo Inoue: Still Life. *Oils; height, 91 cm; width, 116 cm. 1950.*

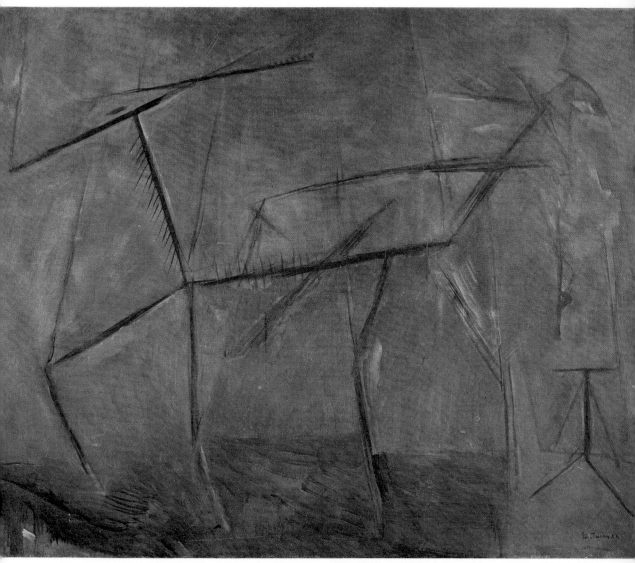

39. Masao Tsuruoka: Marionette Don Quixote. *Oils; height, 112 cm; width, 144 cm. 1952.*

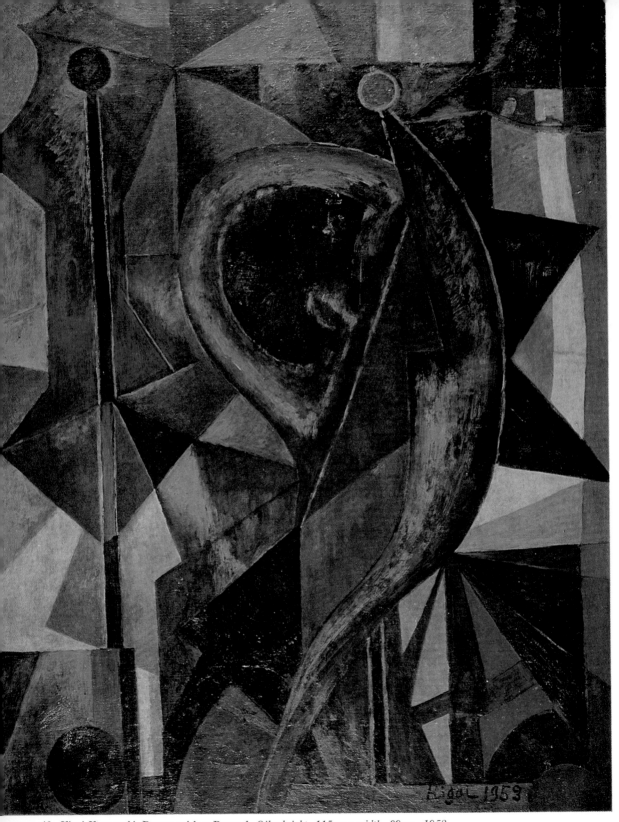

40. *Kigai Kawaguchi:* Person with a Parasol. *Oils; height, 115 cm.; width, 89 cm. 1953.*

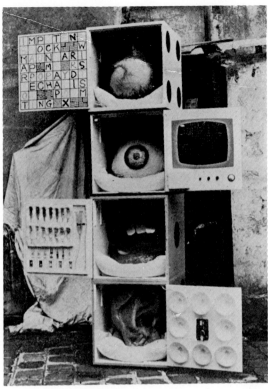

41. *Shoichiro Mori:* Record and Heritage. *Oils; height, 170 cm.; width, 145 cm. 1965.*

42. *Tetsumi Kudo:* Your Portrait. *Wood. 1963.*

the picture, whereas the *informel* artist simply discovers it. The *informel* picture "signifies," but it is not qualified as a "sign" because it keeps changing its meaning. And because of this ambiguity the chance of using several "signs" together to construct a whole seems to be precluded in *art informel.* An abstract painting has a corresponding entity in the real world. Even when the correspondence seems to be irretrievably lost, it is indeed this relationship that retains an "afterimage" of the referent within the picture. *Art informel,* however, lacks such a relationship, and there seems to be no room in it for such concepts as clarity and explicitness.

When a discussion has become as complicated and as argumentative as this one has done, the best remedy is to get away from words for the time being and to take a look at the actual object itself.

This is just as true in art as it is in every other field. Straightforward and concrete observation of the object will often expose a surprising simplicity and truth in what seemed false or confused when it was discussed in purely theoretical fashion. All this difference between abstract and *informel* can be reduced to one point: the presence or the absence of a supranational world view and, if such a view is present, to one's willingness or unwillingness to trust it. When all is said and done, an *informel* painting could be produced by a donkey swishing its tail, but an abstract painting could not.

ART INFORMEL
IN JAPAN
The change in character and the progress of Western nonfigurative painting must have gone a long way toward bringing rest to the uneasy

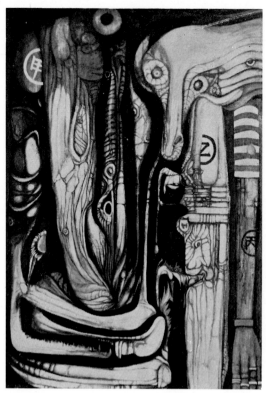

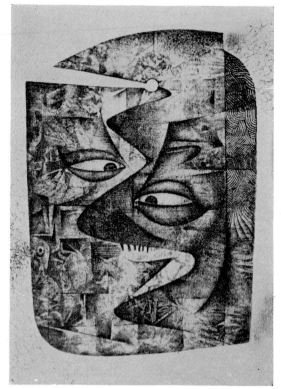

43. Kikuji Yamashita: Gathering for a Funeral. *Oils; height, 91 cm.; width, 65 cm. 1964.*

44. Tatsuo Ikeda: excerpt from the series One Hundred Masks. *Copperplate print; height, 41 cm.; width, 32 cm. 1963.*

minds of Japanese abstract painters, whose works have been variously labeled as psychological, as emotional, as taking natural impressions for their basis, as having Oriental philosophy as a background, or as conforming to a Japanese tradition of artless simplicity. Not one Japanese artist who exhibited works in the Exposition Internationale de l'Art Actuel in 1956 could be considered to have the *informel* style. The reason for the sudden vigor of *informel* that developed immediately thereafter can undoubtedly be found in the exhibition and the sense of ease that it brought to Japanese artists in general. This situation developed without providing an answer to the question of whether *art informel* was actually necessary in a country like Japan, where rigidity of form in abstract art was lacking anyway. It is worthwhile to note that many

of the Japanese artists whose reputation spread throughout the world after World War II employed the *informel* style and that the number of such artists increased dramatically.

In 1953, a group of artists in whose work there was absolutely no *informel* element joined together with the two art critics Shuzo Takiguchi and Takachiyo Uemura to form an organization called the Japan Abstract Art Club. At the end of that year the National Museum of Modern Art organized an exhibition entitled "Abstraction and Fantasy: A Way to Understanding Nonrealistic Art." From the name of the club and that of the exhibition it is evident that *art informel* had not yet entered the minds of Japanese artists at that time. They were still thinking of art styles in terms of realism versus abstraction (or fantasy)—that is, it was a choice

45. Shindo Tsuji: Walking Wall. *Iron; length, 2 m. 1966.*

within the limitations of maintaining form as form on canvas. But abstract art, even at this stage, was often the target of strong criticism. There were many complaints and accusations, including those to the effect that what Japanese artists produced was not true abstraction as seen in the works of Piet Mondrian, in which black parallel lines were finally extracted from concrete figures and, as the simplification proceeded, there was more and more intellectual content in the picture; that the abstraction of Japanese artists was simply obscurity or vagueness; and that because of this obscurity one sensed no reality in the picture.

I have already spoken of the aptitude of the Japanese for the abstract and of their interest in it, but now, having reached the point of reviewing our reaction to the abstract art of 1953, I find that I

must go a little more into detail on the subject. We Japanese have no lack of ability to handle and enjoy abstract things, but we seem to be terribly unskilled in the actual operation of abstracting essentials from concrete things for ourselves. Perhaps because we fear to destroy the attractiveness of the concrete and our love and respect for it, we have a tendency to confine our sphere of activity to the stage just preceding the abstraction process and to the stage following it, but never to the process itself. This is the reason why many of our artists produce abstractlike work but no genuine abstractions. As they came to know the various kinds of Western abstract painting, they found that the same could be said of these works. In fact, that is why such a mass production of abstract art was possible in the West. Whether for good or for ill,

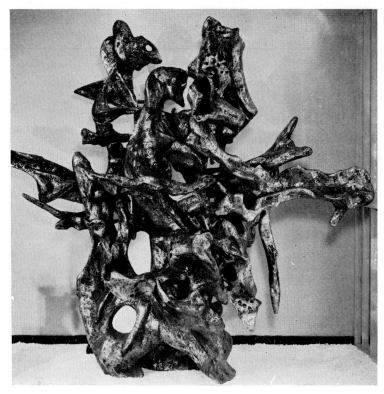

46. *Sofu Teshigahara:* Torikami, *from the series* Kojiki *(Record of Ancient Matters). Wood and copper. 1964.*

it came to be understood that for a painting to be categorized as abstract, it was necessary to have a viewpoint totally cut off from concrete objects. We know, for example, that painters like Jacques Villon are merely manipulating abstract terms.

But rather than take the attitude that this is good enough, we should, as the critics did, expect abstract painting to give us the same quality of pleasure as a rigorous exposition by a disciplined scholar might give us. At any rate, there is nothing against thinking that such expectation in the hearts of the Japanese who would appreciate abstract art was a natural desire springing from their own knowledge of their ability to appreciate it. That is, because we realized the insufficiency of our own achievement in the process of abstraction, we aspired to a high standard, and only because we had searched

out the art style that suited us did we become more acquisitive. As a matter of fact, to this day there has never been a voice among us that declaimed the uselessness of abstract art.

THE JAPANESE ATTITUDE TOWARD ART INFORMEL Our attitude toward *art informel,* however, was slightly different. First of all, since the history of Japanese art had no convention of the domination of form, the negation of form was not considered to be a necessity. On the contrary, we felt that we should be putting our efforts into giving form even to nonfigurative entities.

Still, those who thought this way were not strong enough to keep *art informel* from flourishing. And so we precipitately followed the easy path along

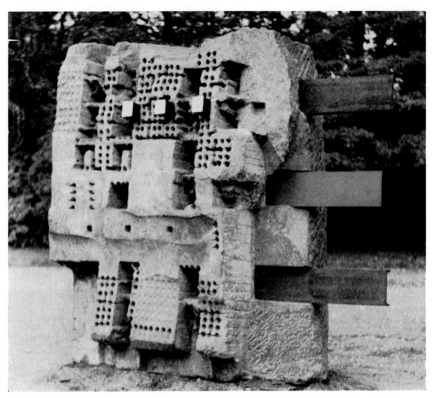

47. *Takeshiro Mori:* Altar.
Stone and iron. 1963.

which our nature and our history led us. But there was another reason for the popularity of *art informel*.

Conventionally, the Japanese have never had any special consciousness of the place where they came to view pictures. Usually, pictures are exhibited in some archaic building in which they do not particularly fit—a building so archaic that no one pays much attention to the imbalance. It may be a building simply made over for displaying paintings; or a building that makes one forget other matters and turn his mind toward the intense appreciation of the pictures; or a building with a bureaucratic atmosphere, chosen for the safety of the paintings, where it is taken for granted that the surroundings do not particularly induce the composure suitable to the desire to view art.

Thus there is usually some difference in time or style between the period of the picture and that of the building, and we are accustomed to employing the historical imbalance in style to separate the building from the observation, analysis, and explanation of the painting. But today's paintings do not allow a perfect appreciation in that kind of exhibition hall—not because paintings have become deeper or more complicated but because of their change in style.

Unlike the figurative painting, in which to a great extent there is a common ground between what the painting represents and our understanding of it from our normal everyday experience, and in which the image is received as an entity in nature, just as the building is, the *informel* painting obstructs our natural desire for sober, step-by-step

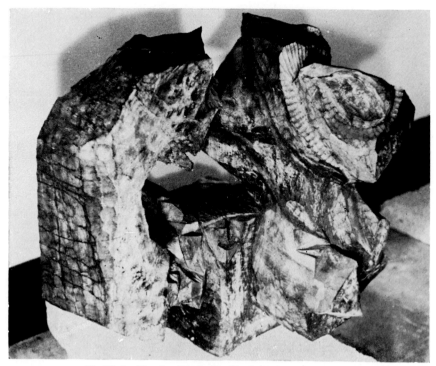

48. Eisaku Tanaka: Work 15. *Wood; height, 130 cm. 1962.*

scrutiny and appreciation and is in basic conflict with the wall of the exhibition hall—if not, figuratively speaking, wanting to flee from the hall. To be sure, the *informel* painting decorates the wall cheerfully, but it cannot be described as hanging quietly there and waiting for the viewer to appreciate it.

What I mean by this is that nonfigurative paintings in general and *informel* paintings in particular cannot be hung just anywhere. They need a special environment, a room or a wall suitably prepared for the purpose, just as the decorative wall and *fusuma* (sliding partition) paintings in feudal castles and daimyo mansions did in the Momoyama period (1568–1603). Works that are unsettling in the ordinary exhibition hall, setting up a disharmony with their surroundings, often seem to become tranquil and soothing when they are placed on the walls of an appropriate building.

Why should this be? One reason is probably that, unlike the buildings of the past, a modern building strongly asserts the thought and the aims of its architect. Furthermore, since it has been efficiently designed to serve its specific purpose as a building, we feel as though we had somehow been formed, nurtured, and used by buildings. But we feel relieved and at peace when we see the indeterminate shapes and colors of *art informel* in such an environment, just as we do when we see a diverting bucolic painting in brilliant colors that takes up a whole wall. Perhaps this is the source of the popularity of *art informel* in Japan.

CHAPTER FOUR

Reaching for New Dimensions

CONTEMPORARY ARCHITECTURAL SPACE AND ART INFORMEL The ideals of contemporary Japanese architecture (which I assume began earlier than 1963, despite my architect friend's remark) and those of Japanese *informel* painting are diametrically opposed in character. So are the achievements of the former and the state in which the latter presently finds itself. This is the very reason why the two coexist harmoniously, the one being the complement of the other. For the walls of modern hotels and office buildings, one finds that *informel* paintings are far more suitable than the landscapes of the plein-airists and the impressionists; the works of Cézanne, Van Gogh, Gauguin, and Renoir; the human figures and landscapes of the fauvists; the still lifes and human figures of the cubists; or even abstract paintings.

In spite of the loss of the universal concept and the regression of the artist's individuality into mere egocentricity in *art informel,* it is nevertheless natural to gather, from the above observations, that for decorative purposes *art informel* is as suitable as —or perhaps even more suitable than—the pointillist works of the postimpressionists. Moreover, we can go as far as to say that only when it is used this way can this art, or semi-art, fully evince its raison d'être. An *informel* painting is certainly not suitable to loving preservation by one individual. The owner of such a painting would not be able to suppress the desire to place it at the disposal of the general mass of viewers. Thus he himself would become merely another member of the general public at an exhibition, and his only connection with the work of art would be the rather abstract claim of being a collector. In a word, this kind of art is not suited to have a person stand long hours in front of it, lost in consideration. Rather, it is suited to exciting and agitating the primitive emotions latent in the viewer or to making him aware of being a latecomer in history.

On the other hand, contemporary architecture is based on the principle that the architect designs the building with much more care and insight as to its purposes and conveniences—in fact, with much more attention than the people who actually live in it or use it can give. And he seems to assume rather confidently that he will succeed in pleasing his client and making him conform obediently to what he has created. In other words, contemporary architecture, produced with elaborate calculation, seems to give full attention to pressing the user of the building into being an absolutely flawless "modernized" man. But the human condition is such that we are not able to conform totally to such intentions and, instead, find relief and relaxation in the indeterminate shapes of *informel* wall decoration, just as we do when we look at the various folk artifacts that have also struck the fancy of our times.

The configuration and the design of contemporary architecture (although even what we call

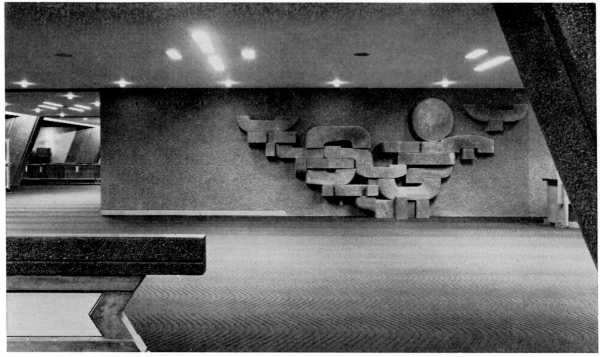

49. Stone relief sculpture on first-floor wall of Kyoto International Conference Hall, Kyoto. 1966.

contemporary architecture has become a kind of classic nowadays) match *informel* paintings quite nicely, as if the two were aiding each other. The reason for this balance lies in the total polarity in the characteristics of the two.

THE LOSS OF INDI-
VIDUALITY IN ART
INFORMEL

This opposition can also be seen in the conflict between the weak individuality in *art informel* and the very pronounced individual expression in contemporary architecture. Since abstract painting became popular, it has become quite normal for an artist to change styles so abruptly, violently, and frequently—for motives beyond the conjecture of any other person—that it often no longer makes sense merely to cite the name of an artist without specifically indicating which period or which work

of his we mean when we use him to exemplify a particular point. And hardly any verbal references can be made to his pictures unless one is provided with photographs of them. This attests to the fact that in the contemporary world in which we live it has become increasingly difficult for one's individuality to gain general recognition as such. For example (and assuming the difficulty of exemplifying), there is the work of Yoshishige Saito (Fig. 52) from the period when it was his usual practice to fill his canvas with red, blue, purple, green, and mostly whitish spots in the shape of flattened cocoons or beans. Tadashi Yamamoto produces *informel* pictures (Fig. 54) that look like the gay and colorful *yuzen* textile designs originated during the Edo period (1603–1868). These artists are said to be quite close to each other in style, but a close look will reveal differences in texture, choice of

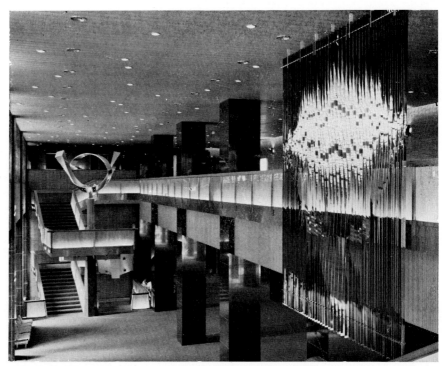

50. *Yoshio Taniguchi: lobby of the Imperial Theatre, Tokyo. 1966. The steel screen at right was designed by Michio Ihara.*

color, and the feel of the surface in general. So there is a matter of individuality here. Still, it is not the kind of individuality that we expect from the artist who devotes long hours to his work so that it is intensely impregnated with his character. What is seen here is no more than a difference in effect and technique. It is not a question of awareness through a deeper etching of the self, reaffirming its difference from others. All traditional painting calmly bears witness to the amount of time put into it by necessity in order that the work exist. But these *informel* paintings do not show even a trace of the time that might have gone into them. *Art informel* is thus characterized not by the artist's individuality but by his loss of identity.

Of course, no one can say that it did not take a long time for Fautrier to produce his many works that look like sparingly glazed pieces of pottery glued to the canvas (Fig. 27) or for Tobey to produce his "white writings." Still, this is something we know only after thinking about it, and we do not have the spontaneous feeling that the artist abandoned himself to time, doling out to the work its ration of hours and giving his very being to it for the sake of its maturity. It is true that the finished pictures of Fautrier and Tobey produce a different effect from those of everyone else, but I cannot help thinking that another Fautrier and another Tobey will appear sooner or later and change the situation completely, for in *art informel* the artist has disappeared from his work, and we can no longer discern his image within it. Ironic though it may sound, this situation has something to do with the reason why artists of the *informel* school so often want to put themselves before the public.

51. *Isao Mizutani:* Banquet No. 18. *Oils; height, 116 cm.; width, 91 cm. 1962.*

52. *Yoshishige Saito:* Work Q. *Oils; height, 183 cm.; width, 122 cm. 1960.*

THE PRESENT: A NEW MOMOYAMA PERIOD

Certainly the work of artist A is going to be different from the work of artist B. But in the work of neither can the existence of the artist be detected. Their paintings become simply decorations whose essence is non-realism. Furthermore, these paintings are not produced for display in the living spaces of private individuals. Instead, they are designed for the decoration of much larger spaces. Such spaces are found within the huge public buildings that are being erected every day—a new form of architecture that did not exist until the beginning of the modern era—as if they were feudal castles of old, which also had their public functions. In the construction of public buildings like these, the respect for privacy rapidly diminishes, and the power of money increases. If we also consider Japan's new relationship with the Western world—a relationship that suddenly inclined our country to prosperity as well as to dilettantism—it seems appropriate to call the present age another Momoyama period, borrowing the name from the age when Japan experienced an influx of European culture through the arrival of Portuguese and Spanish missionaries and traders and when feudal lords decorated their castles in exuberant fashion.

An example of Momoyama decorative painting for public purposes can be seen in the sliding-partition paintings of the Daikaku-ji temple in Kyoto. Here even the realistic peonies are already highly stylized and constitute part of the overall design.

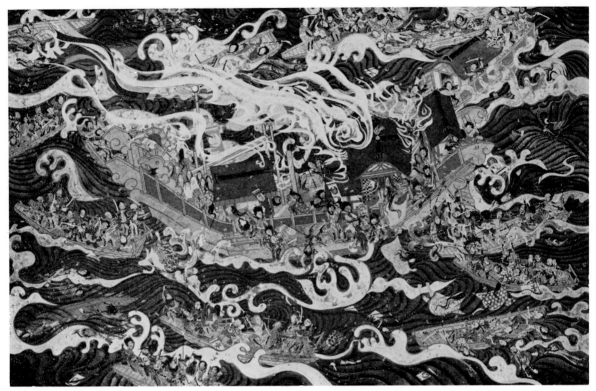

53. *Masayoshi Nakamura: Excerpt from* The Genji-Heike Sea Battle Picture Scroll. *Colors on paper; height, 248.5 cm.; width, 333.3 cm. 1965.*

Whereas the ink paintings of pre-Momoyama times, which in a way resemble abstract painting, evolved from the singular relationship of the artist with his subject matter—separated from all other relationships—in the Momoyama period the prime concern was the effect that paintings would create in the large reception rooms and audience chambers of temples and castles. In other words, the public role of the picture was of extreme importance.

THE PROBLEMS OF REALISM Although it is true that in many avant-garde paintings there is something I cannot altogether go along with, at the same time it is true that when I consider the paintings exhibited today I always detect a certain laziness in the descriptive works, especially when they are of the realistic type, and I cannot help feeling that there is little future in descriptive painting. By laziness I mean the shallowness of mind that I discover in the work of an artist who has found, by pure chance, a subject that he considers suited to his taste (this is something akin to self-satisfaction) and, without questioning the ephemeral quality of the actual situation, happily stays where he is, satisfied with the given segment of reality. Unlike Cézanne, who spoke of going in search of a motif, this sort of artist settles for something that is no motif at all. I believe that if an artist is to be a real artist, he should continue to search for the subject he has not yet been able to find and that, if he has already found it, he has the duty to strip it bare,

54. *Tadashi Yamamoto:* Grand Master of Tea. *Oils; height, 181.8 cm.; width, 260 cm. 1962.*

break it down, turn it inside out, and transform it until it is impossible to tell what it was that originally caught his eye.

Is it really the job of art to present images of things that we see every day as they are—to present, as if they were new discoveries, things that exist in the same space in which we live and must strike most of us as hackneyed? I feel that we all desire a new dimension. This must be the reason that in Tokyo, or even in the outlying areas that still retain some of the feeling of old Japan, we can admire the fresh and clear lines of new superhighways that have completely changed the view of the conventional space.

CREATIVITY IN THE CONTEMPORARY WORLD

Today we are in an era of very feeble creativity. People even seem to have stopped using the word "creative" out of sheer embarrassment. The revolution in technology has been accompanied by the appearance of many new products, so that even today—or most characteristically of today—we are undoubtedly producing many novelties. But we cannot overlook the fact that this is true only in the field of technology, which represents an application of knowledge drawn from the natural sciences. Such productivity does not constitute true creation, for in most cases it is simply a juxtaposition of known elements combined in a new way.

Of course true creativity in the absolute sense of the word was possible only for that which created heaven and earth. It was possible for Prometheus to bring fire to earth because fire had previously existed somewhere else, and he did so because man, who needed it, was already in existence and had already become a maker of things. It is said that in the beginning there was chaos. But the Greek

55. *Shigeaki Kitani:* Torso 5. Cloth. 1965.

word *chaos* originally meant an abyss, and in Greek mythology various entities and gods were born out of this abyss: first the broad plains of Gaea, then Tartarus and Eros, then Erebus and Nyx. These are all said to have been born spontaneously, like the deities of Japanese mythology, but their birth was not a positive act of creation. At least the space that gave birth to these myriad shapes and served as a receptacle for them had to pre-exist.

In the same way, the god of the Jews could not have created heaven and earth separately in a spaceless situation, and as long as the word "light" was not the light itself, what appeared when he said "Let there be light" could not be said to be a true creation. If the word "light" called forth light, then it is the word that existed first, and God had first to create the word. But even if he created the word, how was it that he could have bestowed on it the power of calling up light, since light itself did not exist? Did not the word itself possess that power?

Unfortunately for God, light seems to have existed before he "created" it. That is what made it possible to join the noun "light" to the verbal expression "let there be." If there had not already been light to hear God say, "Let there be," he would not have said it. The word that is commanded by "let there be" must have pre-existed light, and God must have borrowed the power of the word to "create" light. This is what "In the beginning was the Word" means. When the faithful John wrote these words, he immediately felt the need to add that the Word was with God. And then that the Word *was* God. This is simply an amendment to the first statement, but it is an amendment that elevates the statement to a higher dimension —that is, a new statement that transcends the first.

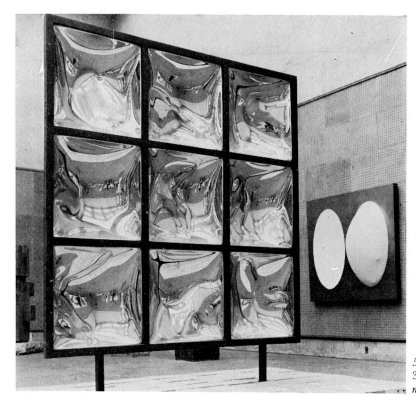

56. *Minami Tada:* Frequency 37306633 MC. *Acrylic and aluminum; height, 3 m. 1966.*

Unless one makes this kind of interpretation, it is impossible to believe in the existence of the world and in God at the same time. But if such an interpretation is made, one has to say that the "creation" of light by God was fulfilled exactly at the moment when he spoke the word "light," before the "let there be" pointed to anything. The light that was, then, was simply the word itself, and there was no creation here either. Even for John, light was not created by God but was a part of him.

Believing that the concept of creativity in art is really the Judeo-Christian concept of creation that extends back to Genesis, I have evolved a bit of spurious theology here. Whether my interpretation is correct or not, true creation is virtually impossible for us, since we have been born into an already existing world and must use already existing materials. What seems to be a creation is really only a new combination of things already in existence or the production of a new external appearance. This view becomes more and more relevant when we look at works of art from the physical standpoint, as it has become increasingly common to do today. In the present age, when neither the canvas nor the painter's pigments nor the plaster, stone, and metal used by the sculptor are the creations of the artist himself, any theory of art that advocates pure creation is doomed to encounter pitfalls. The artist's creativity is just barely manifested in his somehow giving form and appearance to what he has assembled. But the models and near models for his work are increasing day by day, and the great number of such things is obvious. Anyone can easily see that realistic art is the furthest removed from creation with respect to form and appearance, though it does not copy other works of art.

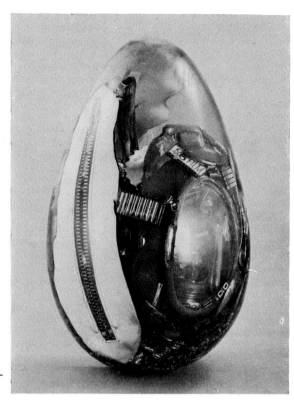

57. Natsuyuki Nakanishi: Compact "Objet." *Various materials; height, 24 cm. 1965.*

On the other hand, what is it that nonfigurative art supposedly creates? Certainly it creates form and appearance that do not exist as such in nature, but it is clearly restricted by being material, since, except for the fact that the nonfigurative work exists firmly as another entity in the world, its unrealistic content does not imprint itself on the mind of the viewer. The very attempt not to rely on images from the external world removes it to that extent from being creative, for there is no one so generous as to give the name of creation to the mere act of trying to describe something in his mind. The sense of decisiveness, which derives from the confluence of as many factors as conceivable, is weak in nonfigurative painting, and such painting has a feeling of tentativeness instead. This is the major reason why we sometimes wonder whether many nonfigurative works are really art or not.

We also wonder whether the artist who produces nonfigurative works could ever produce the same work twice.

ART AND TECHNIQUE It has always been thought that if a thing can be reproduced exactly, it is not art. Unlike manufactured goods and the products of industrial art, which represent the use of easily manageable materials to create like objects over and over by means of a set of specifications, fine art, we have believed, is a product of the unrepeatable act of one-time creation, the production process itself always being pregnant with a new task. At the same time, we have always believed deeply in the skill of the artist who has been instructed, trained, and refined in this act of production, so that, even if he cannot reproduce any of his works exactly,

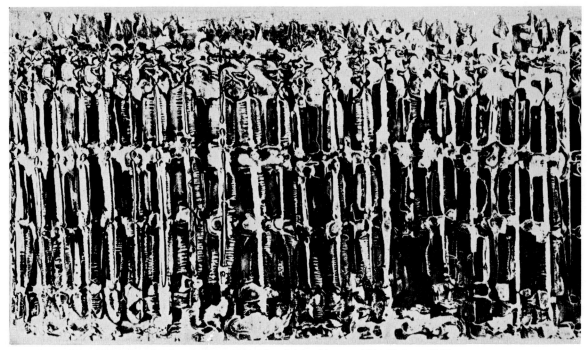

58. *Mitsuo Kano:* Stars: Rumination 1. *Copperplate print; height, 34 cm.; width, 68.5 cm. 1962.*

we think of him as being able to produce a refined and perfected work of the same kind. But the difficulty of grasping and defining the forms in certain nonfigurative works comes in direct contradiction to what we expect of the artist.

Indeed, man is full of contradictions. But is it not the job of art to satisfy our contradictory desires within ourselves? In art, we see the symbol of the creation of this world filled with glory and shame, sin and salvation, love and life and death. But contemporary artists seem to have abandoned the production of works that are, subjectively, equivalent to the whole world. In the second phase of nonfigurative art, I felt a dwindling away of works that were honest, displayed a perfected technique, had an essential originality without aiming at showiness, and kept their fresh flavor without growing stale. Still, my dissatisfaction in the matter of technique was banished in an unexpected manner when op art appeared.

Op art means optic art. It is an "art" that aims at pleasing the eye through an optical effect. Of course, all plastic arts first take hold of a person through an optical effect, and even if a pleasure of the kinetic senses follows—the pleasure of texture in sculpture or of use in architecture—the primary point is the optical effect. And in pictorial art, this endures to the end.

The cubists, by portraying their subjects from a number of simultaneous points of view, freed painting from its bondage to the representation of a single chosen point in time. As a result, the visual images of things, which had maintained stability when viewed from one angle, were now presented in a disrupted condition. Gray and brown spaces intervened within the objects represented; front and back surfaces were shown side by side; a side view was affixed to a front view; and various objects penetrated people's faces. Indeed, the cubists showed themselves to be analysts and thinkers, and

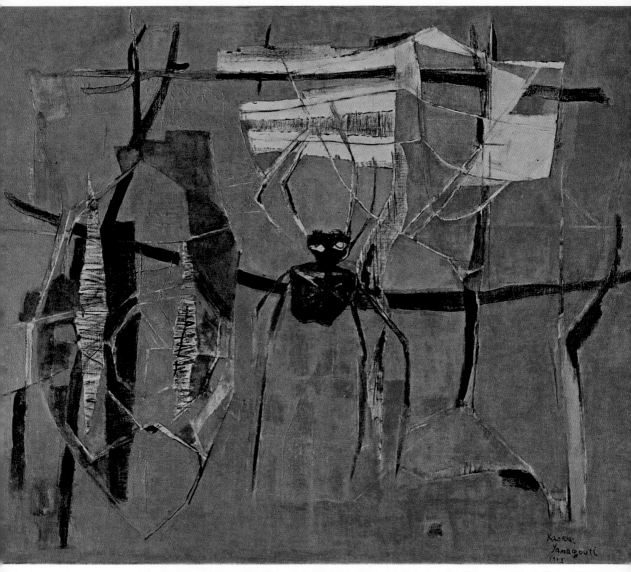

59. Kaoru Yamaguchi: House of a Solitary Person. *Oils; height, 130 cm.; width, 162 cm. 1955.*

61. Yukiko Katsura: Heavy Person. *Oils; height, 61 cm.; width, 72 cm. 1954.*

◁ *60. Jiro Oyamada:* Garden. *Oils; height, 72.7 cm.; width, 60.6 cm. 1962.*

62 (overleaf). Tsunesaku Maeda: Landscape with Figures II. *Oils; height, 163 cm.; width, 263 cm. 1960. Tokyo National* ▷
Museum of Modern Art.

63. *Yoshishige Saito:* Blue. *Oils; height, 90.9 cm.; width, 116.6 cm. 1962.*

64. *Tadashi Sugimata:* Tortoise Shell. *Oils; height, 227 cm.; width, 182 cm. 1961. Bridgestone Art Museum, Tokyo.* ▷

65 *(overleaf). Kumi Sugai:* National Route. *Oils; height, 195 cm.; width, 155.5 cm. 1965. Ohara Art Museum,* ▷
Kurashiki, Okayama Prefecture.

66. *Masuho Ono: untitled work. Spray on wood; height, 181 cm. 1966.*

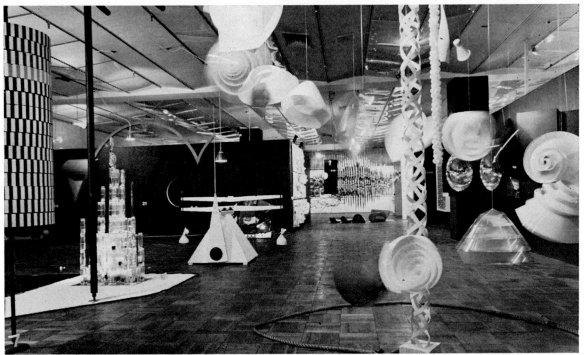

67. *View of exhibition displaying integration of painting, sculpture, photography, design, architecture, and music under the theme "From Space to Environment." Tokyo, 1966.*

68. *Shusaku Arakawa: untitled work. Oils; height, 126.5 cm.; width, 126.5 cm. 1963.*

69. *O Ai:* Rainbow Room. *Oils. 1964.*

they achieved a fair degree of abstraction. But artists like Piet Mondrian, finding the cubist achievement insufficient, evolved the idea of renovating abstractionism, which they felt must free itself from attachment to actual objects.

The neoplasticism of Mondrian was to a great extent already op art, and so, we can even say, was the art of Delaunay. The works of these artists are optical phenomena composed with a totality and a complexity that make them seem to encompass the various phenomena of nature. It seems perfectly natural that there should appear a group of artists who earnestly promote extracting the laws of optics that govern these phenomena and using the laws by themselves without submerging them in the shapes of realistic figures, in various abstract forms, or in *informel* brush strokes—and thereby to produce the surprise and the joy that come from

the embodiment of pure optic phenomena. It seems natural, in a word, because this is an age attuned to putting such laws to work with a minimum of waste motion.

Ushio Shinohara's outsize canvases painted in fluorescent pigments deviate from the above definition of op art in that they are enlargements of such things as the color-print design of a woman's face or the patterns on a giant kite. But Shinohara has another aim in using fluorescent paints besides the simple idea of effectively bringing out the forms he depicts. He uses such paints deliberately in order to make a picture look popular or cheap or to attract the eye to something other than the content. In this sense, these paintings too are a kind of op art, since they are not so much pictorial as they are optical.

With Shinohara's work as one extreme, there are

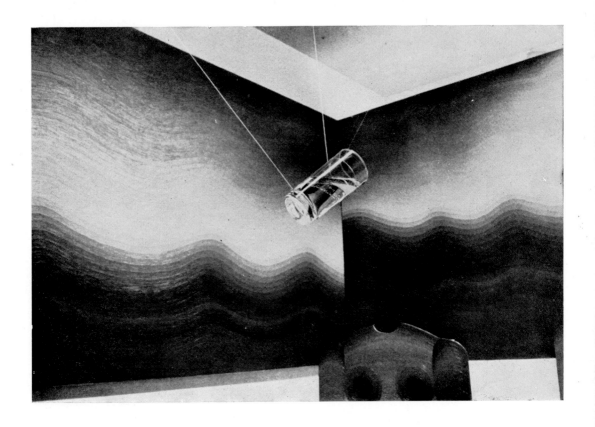

all kinds of Japanese op art to be found—from complex multicolored designs that might be described as a brocade of tiles to monochrome geometrical figures arranged in such a way as to give the viewer a sensation of dizziness (Fig. 66). Still, except for the above-noted works by Shinohara, I think the one special characteristic common to all these works of op art is that anyone could produce the same work as many times as he desired if he were provided with a precise plan, a set of instructions, and a sample.

THE DESIRE FOR ORDER

I am not quite ready to believe that the era of integration in the postwar period has begun, but I think it can be said that contemporary art shows a nostalgia for a certain synthesized order. The efforts in this direction so far,

however, represent only the individual artist's realization, by his own method, of his own narrow order. As a result, no one has yet come to grips with the problem of disunity among fellow artists doing the same kind of work or the problem of whether they can resolve the differences and give guidance to those who use completely different techniques. In this sense, we seem to be still in an era of nihilism, although it is nihilism with an optimistic coloring.

Then what is the artist trying to say about humanity in following current art trends, presuming he is trying to say something? I think that works of the sort produced today, although there are hard-soft and cold-hot differences among them, invariably show the conceit of the artist who has renounced the authority granted him by his fellow human beings and isolated himself from them, at the same

70. *Mokuma Kikuhata:* Roulette No. 1. *Colors on wood. 1964.*

71. *Tadanori Yoko-o: poster advertising Yukio Mishima's book* Aesthetics of Termination. *1965.*

time being unaware of what he has done and seeing no particular tragedy in his existence. He is no more than a man who waits to hear the voices of the art dealer and the critic and looks forward to a broad popularity. To such an artist we might well say: "Certainly, if we admit your methods and your aims, then you have done well. But what is it, exactly, that you are trying to appeal to in humanity through these methods?" If we ask this question (as we always want to do), will the artist reply that he does not intend to appeal to humanity but to society instead?

Toward New Uses of Space

ARCHITECTURE AS THE CORE OF CONTEMPORARY ART

The sense of being creators has weakened among artists, and today we have works that speak of revolt or separation from the mainstream, works born out of an overconsciousness of imitating such and such an artist, and works in which all the effort is poured into following exclusively the principle on which a particular art form is based. As a result, we have pictures that cannot be distinguished from designs, art objects made to look like exact copies of certain common everday objects, sculpture for the blind, and so on and on. This is the age when man's greatest creative energy is being used in technology or applied science—and being used quite effectively. We can see all around us the materialization of many new ideas through architecture as an applied science, evincing a revolutionary vitality seldom seen in other fields of art.

Why is it that, amid the general deterioration of artistic production in general, only architecture continues to rise to higher and higher levels of achievement? I think the reason is basically that it is necessary by nature for architecture to give birth incessantly to larger and totally new forms—that it can maintain its existence only as long as it continues to develop.

Painting and sculpture can become the objects of insult and scorn if they decline from accepted standards, but inferior creations of architecture are regarded as mere technical products, not as examples of architectural art, and hence escape denunciation. In a word, every painting and every work of sculpture is subject to artistic criticism, and works that have no artistic value are condemned, in the name of art, to disappear, to be made light of, or to be ignored. But architecture is necessary for the daily existence of man. Even structures that have no relation to art serve to shelter man from the weather and to house goods and possessions that require protection. If only because of these functions, such buildings are respected. By the same token, there is not much need for changes in architecture if it serves only to fulfill such needs. It is for this reason that a structure is considered as architecture and, from the traditional point of view, as art, if something is added to the original mode or if some modification is made so that it becomes conspicuous. As a friend of mine once lamented, "If all you want is a house that doesn't leak, a carpenter is good enough. I guess what I do best is a building that at least leaks a little."

ARCHITECTURE AND MASS SOCIETY

The fundamental reason why outstanding architectural works of new design are constantly being built today is that we have arrived at a time when nothing can proceed without taking the vast public into consideration—such great masses of people as had never been imagined before. Cultural centers, gymnasiums,

72. Tsutomu Ikuta: house with right-angled roof, Tokyo. 1960.

public halls, temples and churches for new religions and old, business offices, hospitals, dams, superhighways—all these are structures for whose operation only a limited number of people had to be taken into consideration in earlier days. Now the large amounts of money invested in them are commensurate with the amount of their future potential income. One might say that the main reason for the flourishing state of large-scale civil-engineering and architectural projects is the relative ease with which it has become possible to make profit estimates. As soon as a monument with a spiritual connection is put up, it is tied in with some sort of tourist business or other. The financiers who counted on the 1964 Tokyo Olympics were certainly disappointed, but the huge buildings they constructed are now being used for other purposes, as expected, and there has actually been little loss to the financiers after all. There have never been

any masses so easily mobilized as those of the present age.

LIVING SPACE On the other hand, there has never been a time when the names of designers of private homes have been so widely publicized, or when their designs have received the careful attention of so many people. Today, for the first time in Japanese history, the private home can be recognized as the creation of an individual. Still, in private housing in general, we are probably in need of a new concept diametrically opposed to the present-day mass character, for the private house is not built with the intention that the owner-user who commissions it will get a clearly commensurate profit in return for his expenditure. Rather, it is built to answer the individual's desire to escape from the increasingly mass character of today's society.

73. *Kazuo Shinohara: house with broad roof, Tokyo. 1964.*

At the same time, I cannot avoid seeing, in almost every contemporary private house, a certain restriction that the architect imposes upon the type of person who lives there. If the resident does not fit within the limits of the idea that the architect has of him or if it is necessary to violate this idea, then he must abandon his residence. That is to say, the maturing of the resident in the architectural sense has not been taken into account at all. The house has become simply a container for the typical contemporary man who detests living in one of the mass apartments built by the Public Housing Corporation or in one of the stereotyped wood-frame houses of old. The man who has escaped from the past only to be trapped by the present and is trying to escape once more is doubly denied a place to live.

In order to avoid such unhappiness, one has to become rich enough to own a number of houses in different styles. In fact, any rich man's mansion built on an extensive tract of land with what appears to have been an enormous amount of money has actually been designed to create a nostalgic feeling of peace. Certainly, without the accumulation of wealth we cannot hope for good architecture, and therein lie both the glory and the tragedy of architecture today. We must bear in mind that behind the flourishing of contemporary architecture in Japan lies our economic prosperity, which we cannot positively say does not leave us somewhat conscience-stricken.

But, besides current economic conditions, there must be a reason inherent in architecture itself that is undeniably at the root of the progress in present-day architecture, which vigorously continues its production. As an applied science, architecture rejects the arbitrary ideas of any given individual. Because of the inevitability of this

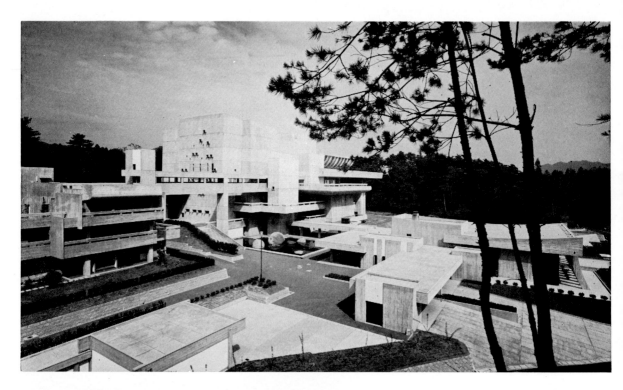

74 (above). *Taneo Oki and Yukio Otani: headquarters of the religious sect Tensho Kotai Jingu Kyo, Tabuse, Yamaguchi Prefecture. 1965.*

75. *Kunio Maekawa: detail of Tokyo Metropolitan Festival Hall, Ueno, Tokyo. 1961.*

76. *Kiyonori Kikutake:* A City of the Future. *Model. 1959.*

characteristic, the architect accepts moderation in inventiveness as a matter of course. By adding only a little originality at a time, he is able to keep from dropping behind the front line of production. Thus he is kept from making plans that might lead to self-destruction brought about by competition or by a psychology of self-abandonment, which is quite possible in painting. Moreover, the architect must respect the aim of the product and its limits. By planning within these limits, he is able to save his originality from being carried away by arbitrariness. In addition, technological advances have produced a wealth of new building materials, while advances in civil engineering have produced more solid foundations. These advantages have certainly facilitated and promoted the variety and the refinement of the architect's ideas.

SPACE IN CONTEMPORARY ARCHITECTURE It is not far from correct to say that all these factors are propelling contemporary architecture in the direction of giving us not merely visual pleasure but also what might be called the ideational pleasure of new spatial and kinetic sensations.

What are the new points that characterize all contemporary architecture? An obvious one is the tendency to get away from the control of vertical lines. Although there are differences in taste among individual designers, this tendency is commonly found in such representative buildings as the Tokyo Metropolitan Festival Hall (Fig. 75), whose soaring walls slant ever so slightly inward toward the top and whose overwhelming immensity makes us think of a work of civil engineering rather than of

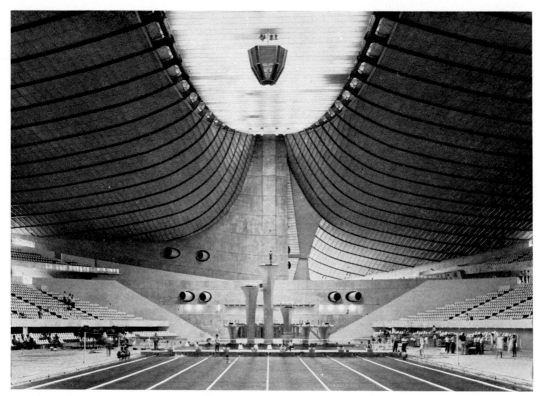

77. *Kenzo Tange Research Institute: National Indoor Stadium, Yoyogi, Tokyo. 1964.*

architecture, and the Kyoto International Conference Hall (Fig. 111), which suggests a pile of Shinto temple roofs with their massed ranks of projecting rafters—or perhaps the roofs of ancient Japanese pit dwellings, some placed upside down on top of others placed right side up.

In the National Indoor Stadium in Tokyo (Figs. 1, 13, 77, 78) the catenary of the main supporting cables, which correspond to the ridgepole of an ordinary structure, suggests an enlarged version of the swinging curve displayed by the roof of an ancient Buddhist temple seen from a distance. One of the special characteristics of the stadium is the twist of its suspended roof—a feature that cancels the vertical effect of the main pillars. Viewed from the east, near the entrance (Fig. 1), the nearer main pillar looks like the slender point of a broad-skirted

ascending spiral. Indeed, this tremendous roof, with riblike lines of tiles running through it, has the appearance of gigantic wings and seems to be on the verge of either leaping into the sky or plunging into the earth.

To what extent was Kenzo Tange, chief architect of the National Indoor Stadium, aware of this idea based on what might be called an irregular interaction with the ground? Tange himself has said: "At the designing stage, there were twenty people working together on spatial design alone. Even though the same group worked together every day, each member had his own strong individual character. They expressed their individuality in their ideas of dimension and configuration, their feeling for materials and color arrangement. So, when it came to handling this kind of indeterminate or ir-

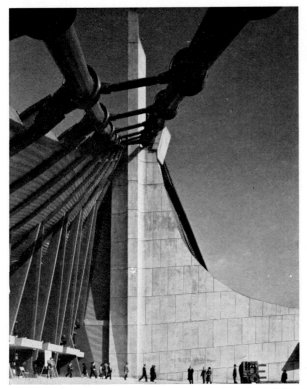

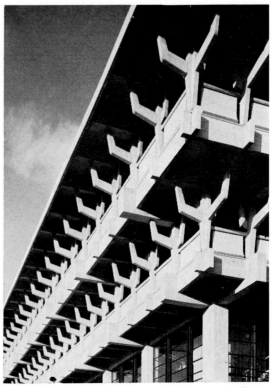

78. *Kenzo Tange Research Institute: detail of National Indoor Stadium, Yoyogi, Tokyo, showing main supporting cables for suspended roof. 1964.*

79. *Koji Kawashima: eaves of Tsuyama Cultural Center, Tsuyama, Okayama Prefecture, after the fashion of traditional Japanese roof-supporting brackets. 1966.*

regular spatial composition, with literally nothing to hang on to, their individuality was apt to come through very strongly. Still, in this kind of architecture, most important is formal coherence."

For the very reason that coherence was achieved, the gymnasium was able to carve out a place for itself, so to speak, in what was once the western part of the old city of Tokyo, its novel design cutting adroitly into the surrounding space. Not only this, but more significantly, and for the same reason, it attained the level of true architecture.

It is most important to note that Tange pictured the space he was to compose as being of indeterminate form. At the same time, it is worthwhile to note his opinion that because of the concept of *informel* space displayed by the gymnasium, individuality tended to come more and more into play.

Tange has also observed: "In this case, the configuration of the catenarian cables is the keynote for the feeling of unity of form. But in order to produce the catenary you need a foundation to support the cables. The catenary is made possible by the tensile strength of steel, and what you need in the foundation is a high compression capacity of concrete [Fig. 78]. It was at a fairly late stage that we brought in the arch and, as a variation of it, the 'conoid' aspect as an expression of the compressibility of concrete."

The arch referred to here is the sloping curve extending over the upper end of the spectators' stands (Fig. 77). Of this curve, which serves to demarcate the spectators' area, Tange says: "This arc drawn in space functions structurally as a gigantic slanted arch." The reason for his use of the word

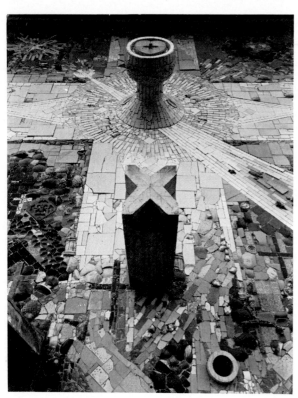

80. Kenji Imai: detail of Information Center, Memorial Chapel for the Twenty-six Japanese Martyrs, Nagasaki, showing Gaudi-st le mosaic decorations. 1962.

81. Kenzo Tange: St. Mary's Cathedral, Tokyo. 1965. ▷

"conoid" is probably that in the floor plan the slanted arch, whose plane is oblique, is projected as the arc of an ellipse, and a vertical cross section presents it in the shape of a quarter moon. Three-dimensionally, these are the properties of a cone.

What is surprising to us laymen is, first of all, that even in design new ideas arose after the work had already begun and, second, that certain achievements were the result of groping around in the dark, so to speak. And it is of special note that such processes come under the definition of what we have labeled *informel*.

On the other hand, it is quite natural that the architect should have asserted his will in order to regulate the fractious tendency inevitably latent in anything *informel*. His confidence derived from modern progress in technique, materials, and methods of computation—progress that facilitated the

action of his will—and from his optimistic belief that he could fulfill his voluntarily imposed duty by riding on the tide of technical progress rather than by adhering to traditional methods.

In this fashion, the conventional architectural ideal of vertical pillars, horizontal beams, and right angles, which has up to now given us a sense of security, has been rejected. The National Indoor Stadium has made its appearance in the shape of a conch split in two, the directions of the two halves reversed and meshed together in the middle, and the stands look like two crescent moons facing each other slightly off center.

The tendency of contemporary architects to experiment on designs in which stability would have been impossible and the architectural results would have been dubious with traditional techniques and conventional materials can also be seen, on a small-

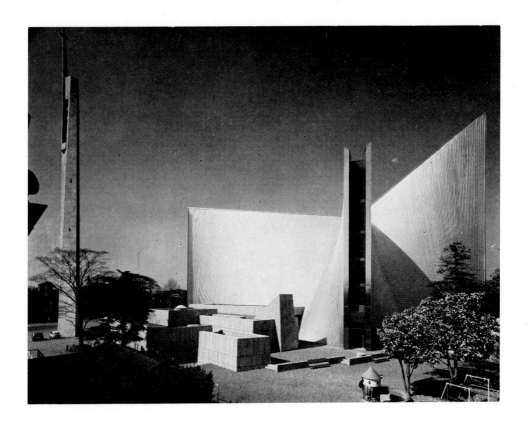

er scale, in Tsutomu Ikuta's residential designing. Ikuta has developed the house with a right-angled roof (Fig. 72), a structure in which one section of the roof descends at a deep slant to connect with a low wall, while its interior side forms a steeply sloping ceiling.

While conventional buildings have to rely on the strength of their materials to maintain stability, the architect-designer of the new trend uses every possible computational device that enables him to make his will and his desire permeate the structural scheme to an extent far greater than traditional methods allow. Because of the results of his "structural calculation" compressed in his plan, the structure maintains force and dynamism. At the same time, such a structure gives us the impression that it intends to do away with space rather than to fill it and give it form. In fact, there

are numerous recent buildings that remind us of battleships. It is also true that certain new buildings made of stone, a material that cannot be handled with great flexibility, look much lighter than steel-and-concrete buildings that are supposed to be closer to a direct representation of the ideas of the architect. For this reason, although the ornamented, slightly awry, lanky, and tapered spires of the Memorial Chapel for the Twenty-six Japanese Martyrs in Nagasaki (Fig. 113)—somewhat reminiscent of Gaudí—are of a capricious, dexterous, and free form, what I see there is tenacity and firmness rather than delicacy and sprightliness. In this respect, I find a resemblance between contemporary architecture and that of the ages when Japan was ruled by the warlord Toyotomi Hideyoshi (1536–98) and then by the Tokugawa shoguns—men who mingled human elements with

purely functional elements in the architecture of their castles and mansions. The inward-sloping walls of such structures as the above-mentioned Tokyo Metropolitan Festival Hall impress us in the same way that the common people of earlier times were impressed by the sloping stone walls that soared up to the keeps of feudal-age castles. Similarly, the kind of designing that permits the addition of extra quarters to let the residence "multiply" horizontally, as in the instance of Hideyoshi's great castle-palace Juraku-dai, built in Kyoto in 1586, seems to have been resurrected in present-day architecture.

THE DESIRE FOR DÉFORMATION

The rise of new forms in Japanese architecture can be better understood if we take note of the fact that postwar Japanese literature began with the rejection of realism, accompanied by the enthusiastic hailing of such works as Kafka's *Metamorphosis,* and that, in the fine arts, the word *déformer* was used popularly in Japan even before the words "nonfigurative" and "abstract" came into general use. In fact, the word *déformer* was used by so many people that it was regarded almost as a universal formula in plastic art. This situation came about during the collapse of the social order and the confusion in the visual arts that accompanied the end of the war. We can see now that the artists of that time adopted a model suggested to them by the world before their very eyes and that they refused to bring order out of confusion and to reconstruct the art world as it had been because to do so would mean only to return to the former oppressive and suffocating structure of things. No matter in which genre of

82. *Nikken Sekkei, Ltd., Planners, Architects, and Engineers: Palace-Side Building, Tokyo. 1966.*

83. *Takamasa Yoshizaka: Gotsu City Office Building, Gotsu, Shimane Prefecture. 1962.*

art—photography, cinema, painting, or sculpture—people were trying to escape, by means of this model that rejected any model, from prewar patterns. We can say that the so-called *après-guerre* unconventional life styles in postwar Japan were traits of *déformation* that appeared in ordinary life.

In architecture, the desire for *déformation* began to solidify only recently in the manner outlined in the previous section. That is to say, the change in architecture from the practice of using forms divided only by vertical and horizontal lines to a search for new configurations can be attributed to the desire for *déformation,* one of the basic postwar aspirations.

We need not be surprised that the revolution in architecture lagged behind the revolution in the other arts. Architectural activities are not recognized as such when they are at their incipient stage

or in a state of stagnation. With intellectual vivacity alone, architectural works worth listing in the history of art cannot be produced, for architecture reveals its value overtly only after there has been some accumulation of wealth. It is not surprising, therefore, that the same kind of intellectual desire that arose in other genres of art early in the postwar period took some fifteen or sixteen years more to manifest itself in architecture.

Many of the representative works of contemporary Japanese architecture have a very heavy feeling both in external appearance and in interior structure, and there is much use of materials rough to the eye, as well as a love of a rich variety of unusual textures. These characteristics correspond to those of the first *après-guerre* tendency in Japanese literature following World War II. One may argue that for this reason *art informel* is not well suited to

84. *Taro Okamoto: Ceramic wall decoration on first floor, Tokyo Metropolitan Government Office Building. 1957.*

85. *Keiji Usami:* Old-fashioned Arcade. *Oils; height,* ▷ *220.5 cm.; width, 176.5 cm. 1965.*

the walls of such structures. In fact, the works of artists like Taro Okamoto (Fig. 84), Kinosuke Ebihara (Fig. 92), and Masao Tsuruoka (Fig. 39) —and perhaps those of Chozaburo Inoue (Fig. 38), Masaaki Terada, and Wasaburo Itozono—are more appropriate than works in *informel* style, as are also, perhaps, the abstract paintings of Takeo Yamaguchi (Fig. 11), Kaoru Yamaguchi (Fig. 59), and Kigai Kawaguchi (Fig. 40).

Since *informel* painting advocates anti-intellectualism and has as its method an explosion of sentiment or an intuitive fixing of ideas, I do not think it would be able to endure the antagonistic tension that would be set up between it and the intellectual character that even the kind of architecture we have just mentioned displays. Conversely, I think, the denial or destruction of regular form

—the characteristic common to both *informel* painting and contemporary architecture—would not allow the creation of sufficient tension for mutual support. This speculation, born of the suspicion that adequate tension cannot exist either between entities of exactly the same character or between entities of directly opposed character, may on the surface seem paradoxical. But the first of these tensions is an internal one that, if it comes into play, creates a harmony between the structure and the painting that decorates it, while the second one is an external tension that, once established, pleases the eye of the viewer. If a stylistic or visual opposition of the latter kind is produced in a situation in which the internal tension—or the balance in the intensity of intellect—has been restored, the relationship between the decoration and the building

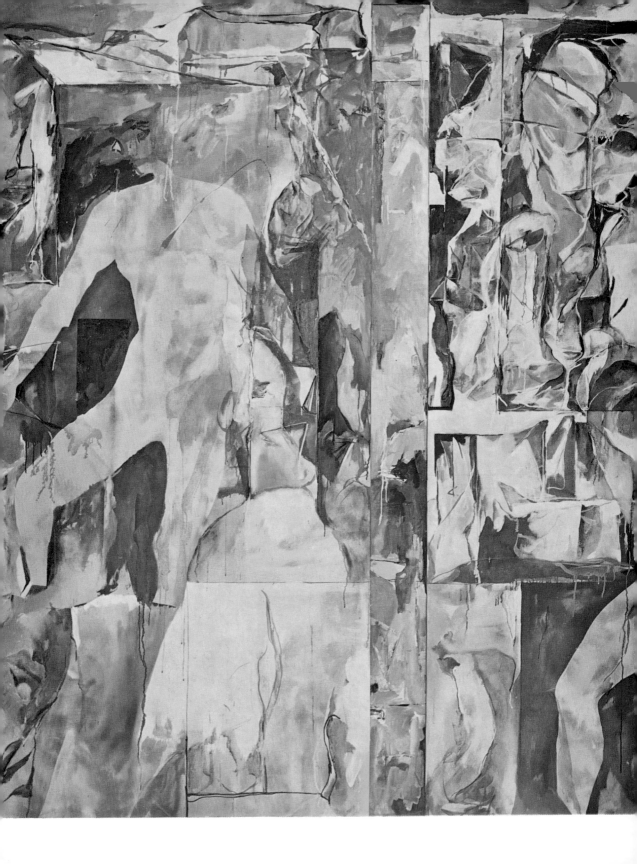

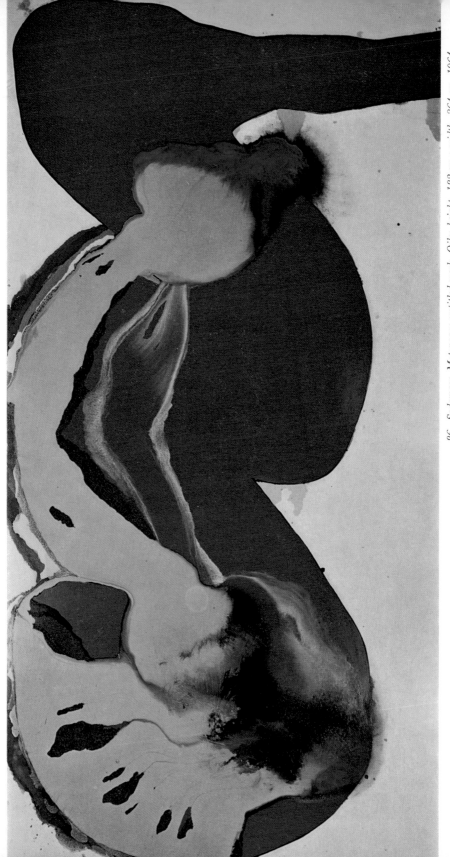

86. *Sadamasa Motonaga: untitled work. Oils; height, 182 cm.; width, 364 cm. 1964.*

87. *Taku Iwasaki: detail from Aesthetics: America. Aluminum collage; height, 183 cm.; width, 244 cm. Tokyo National Museum of Modern Art.*

▷

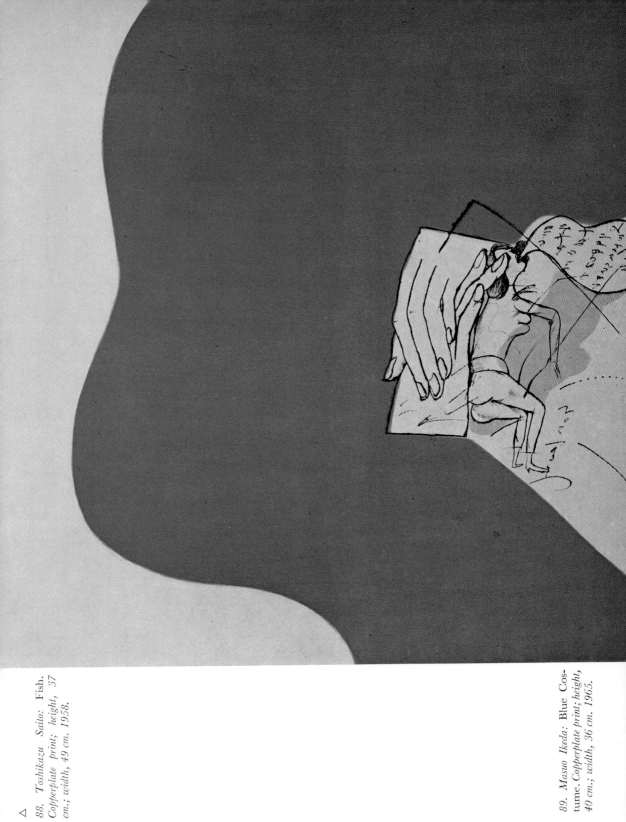

△
88. *Toshikazu Saitō: Fish. Copperplate print; height, 37 cm.; width, 49 cm. 1958.*

89. *Masuo Ikeda: Blue Costume. Copperplate print; height, 40 cm.; width, 36 cm. 1965.*

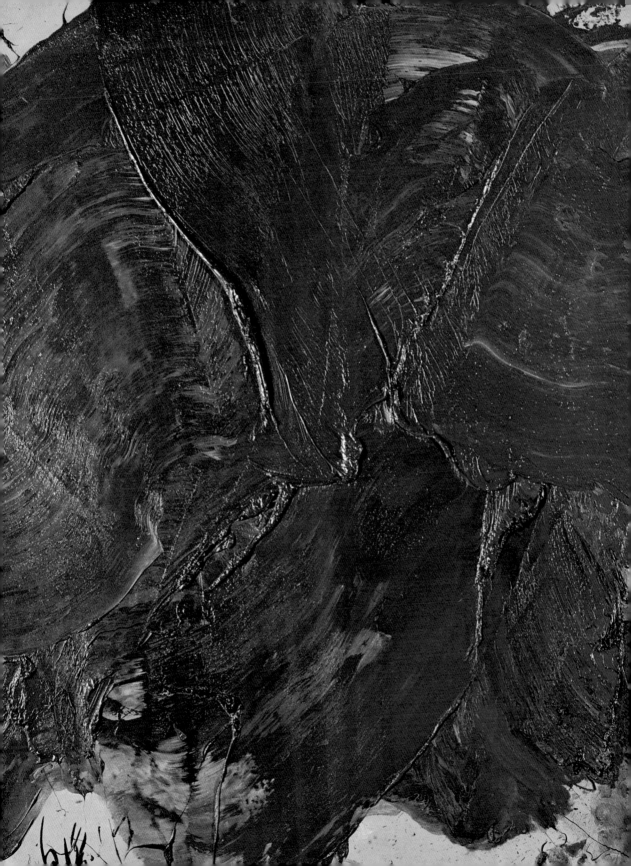

90. Kazuo Shiraga: Vermilion. *Oils; height, 213 cm.; width, 273 cm. 1965. Nagaoka Museum of Contemporary Art, Nagaoka, Niigata Prefecture.*

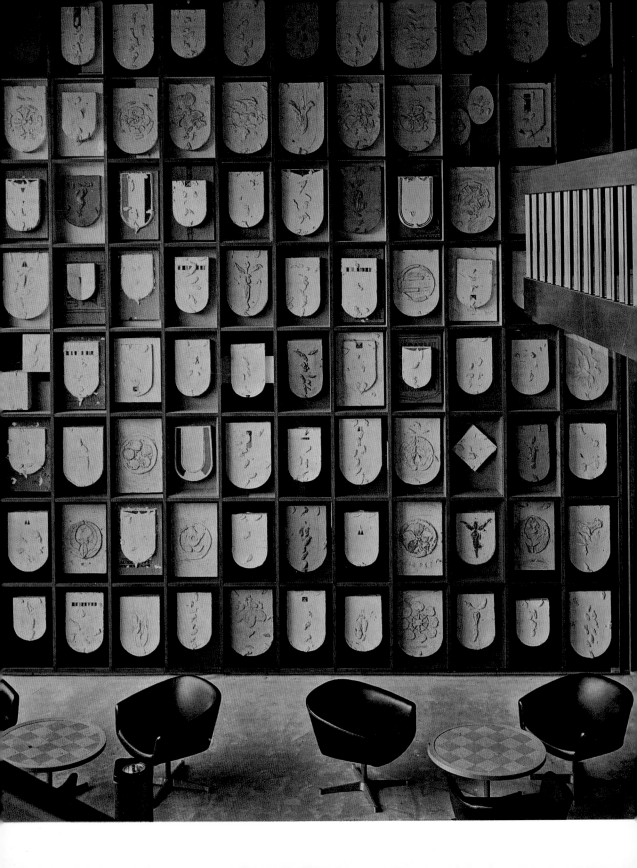

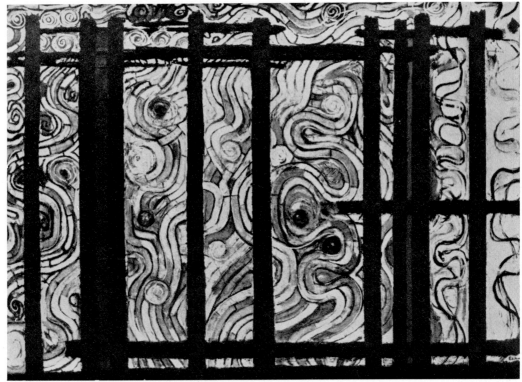

92. *Kinosuke Ebihara:* Burning. *Oils; height, 181.8 cm.; width, 260 cm. 1957. Nagaoka Museum of Modern Art, Nagaoka, Niigata Prefecture.*

will be much improved. This premise is the basis for imagining that the most appropriate wall decorations for this kind of architecture will be the works of artists who produce allegorical or fantastic paintings nonrealistically but, at the same time, figuratively—that is, by distorting images taken from reality or by using them in unrealistic combinations—or the works of artists whose abstract figures, while not necessarily derived from real objects, nevertheless remind one of reality rather than of anything in the mind of the artist, or, again, the works of artists who are conscious of what might be called a classical opposition between concrete and abstract.

CONTEMPORARY SCULPTURE

In this connection, what is the new trend in sculpture? Contemporary sculpture takes the form of walls with unusual surfaces displaying varied textures, of huge stones incorporated into the structure of a floor or a garden, or of immense free-standing ornamental works. But, then, how is a piece of sculptural work different from an ornament? The difference is probably the same as that between a sculptural work and a doll. The shape of a doll is molded by adding materials from outside, whereas in sculpture what is most appealing is the sense of the existence of the entire material made into a shape rather than its external

◁ *91. Yukihisa Isobe: wall sculpture at offices of Zenkyoren (National Mutual Insurance Federation of Agricultural Cooperatives), Tokyo. 1964.*

93. *Kazuo Yagi: ceramic object in black. 1964.*

appearance. The same holds for work in plaster and clay, in which there is an addition of material to the base, as well as for direct carving. The discrepancies between a doll and the model on which it is based—especially the discrepancies between a lifelike doll and the person who models for it—can be concealed by reworking and patching over, but in sculpture there is no room for such "courtesy" or impudence.

One might argue that such a difference between a sculpture and an ornament is really nonexistent and that a sculpture is an ornament if it is used as an ornament. But I disagree. An ornament is limited to the purpose for which it was manufactured. In short, it is the product of applied art. It is true that some old vessels of pottery and copper have no fixed pattern and do have the configuration and the weighty feeling of sculpture. But the

fact that they were designed for utilitarian purposes and on the basis of predetermined shapes only proves that the products of applied art are different from sculpture. In this sense, almost all the statues of the Buddha and of Buddhist patriarchs made during the Edo period (1603–1868) are either dolls or ornaments, and the reason why they leave a sickly impression is that they lack the "courtesy" of hiding their inappropriateness. It is not worthwhile to discuss ornaments based on traditional subjects and cast in molds from which any number of them can be made for commercial and other purposes.

Still, I should like to look into the question of whether even contemporary sculpture, with its unusual and unduplicable shapes, does not have some similarity to ornament. Certainly it does not have that special capacity of sculpture to draw people

94 (right). *Noboru Oda:* Between Yesterday and Tomorrow. *Iron. 1966.*

95 (far right). *Kentaro Kimura:* Seven Rice Cakes. *Stone; height, 90.5 cm; width, 31.4 cm. 1965.*

to itself simply by being placed on view. The larger works, in fact, seem to have become part of the place where they are displayed.

Contemporary sculpture, being nonfigurative and therefore, to a great extent, having no meaning that can be directly grasped, claims to be created with the intention of giving pleasure purely through its shape and the texture of its material. But there are few works that seem to have achieved their shape through a necessity latent in the material itself. Instead, the shape seems to have been arbitrarily imposed upon the material. For this reason a large number of contemporary sculptures can be criticized for not displaying harmony between the pleasing shape and the attractive texture of the material.

The present trend in Japanese sculpture can be seen in the tendency to praise such things as the attempt to render in hard stone the soft form of the pounded rice cakes offered to the gods at New Year's (Fig. 95). In another area of sculptural activity, there are works welded together from parts prepared by a blacksmith following a set of instructions (though the artist may be present at the forge) or from scrap metal found on the street or in the corner of an iron factory. But instead of carrying conviction by giving an impression of weight and strength, many such works are accepted because they are well organized, trim, or delicate in spite of the disparity of their materials. Here we have another glimpse of the tendency of sculpture to become ornament.

What I have suggested concerning *informel* painting also applies to most of today's sculpture, which seems to have given up trying to attract people and encourage them to meditate upon it for a while. It

96. *Workshop site of World Modern Sculpture Japan Symposium, 1963. Cape Manazuru, Kanagawa Prefecture.*

seems to be satisfied with only drawing a casual glance now and then.

The increase in the number or works displayed outdoors or made for outdoor use is certainly another characteristic of contemporary sculpture. But most of these works stand out only because they are displayed in large, uncluttered spaces. If they were carried indoors, they would undoubtedly be very inconspicuous objects. One might say that they are too large to be suitable for indoor decoration anyway, but one cannot cite the reason that they are too powerful to be thus confined.

CHAPTER SIX

The Reawakening to Tradition

WE HAVE ALREADY NOTED a tendency in contemporary Japanese architecture to deny and demolish architectural concepts of the past. It would be a mistake, however, to assume that what is being rejected or destroyed is native tradition. Indeed, the reverse is true. What is denied is the hexahedral concept of architecture, which in any case is quite foreign to traditional Japanese architecture. Today, whether the increase is intentional or not, various elements of traditional Japanese architecture are being used more and more in the form of decorative structural details, although not in the form of basic structure. One example of this tendency is to be seen in the lobby of the Kyoto International Conference Hall. Here a sculptured wall decoration incorporates elements resembling the traditional roof-supporting brackets seen in Buddhist temples (Fig. 49). Another example is the use of architectural docorations that remind us of traditional Japanese latticework (Fig. 97).

As we have observed before, Japanese architecture did not settle on *déformation* as soon as World War II ended. The reason, of course, was basically an economic one. In order for an architect to represent in material form and within his own discipline the new trend of thought that he is conscious of following—no matter how anticapitalistic an ideology it might be—he must wait for wealth to accumulate. But is this the only condition to be considered? Unlike painting (which anticipates a new era in art) and music (which echoes it to complete the picture), architecture produces works representative of an era only when the *Zeitgeist* of that era is at its zenith. Therefore, aside from the delay caused by Japan's extreme poverty after the war, we must consider another condition to account for the new trend in Japanese architecture —a condition, that is, other than economic.

HORIZONTALISM In Japanese architecture dating from before 1960 (to be more precise, in the monumental buildings pictured in representative books on architecture) there is already some use of slanted vertical lines in columns and buttresses or in the body of the structure itself—lines that produce a shape inclining inward at the top or even at the bottom, where it seems to thrust like a wedge into the earth. But even more apparent is the unprecedented abundance in which pronounced multilayered horizontal lines are used. While the slanted vertical line shows a long, gentle, and modest inclination from the perpendicular, the horizontal line is lengthened to make it stand out as much as possible. There is often very little distance between upper and lower lines, as if to show a casual relationship with the earth. The accent of vertical lines is suppressed to a surprising extent. Even buildings that boast of their height emphasize the horizontal line most vividly.

Horizontal lines are most typically used in the designs of prefectural and municipal government office buildings, civic halls, and private residences.

98. *Eaves of Five-storied Pagoda, Daigo-ji, Kyoto. Mid-tenth century.*

97. *Kiyoshi Awatsu: door design, Treasure House of Izumo Grand Shrine, Shimane Prefecture. 1963.*

99. *Kenzo Tange: balconies of Kagawa Prefectural Office, Takamatsu, Kagawa Prefecture. 1958.*

It may be reckless to take this as evidence that the Japanese forgot about rising again after the Pacific War, but perhaps we can view it as evidence that they have come to feel more at ease with the leveling process. It may sound like a good explanation to say that this reflects the Japanese desire for democracy, but the reality is that it reflects the relief of being able to settle down at last.

At the same time, the tendency toward horizontalism seems to reflect a return to the spirit of traditional Japanese architecture. Aside from the three-storied and five-storied pagodas of Buddhist temples and the donjons of feudal-age castles, there were no high buildings in premodern Japan. Undoubtedly this phenomenon can be explained by such natural factors as the frequency of earthquakes, the scarcity of stone, and the wealth of good wood, but the important point is that the premodern Japanese

were a people who, even in the case of the nobility and the warlords, had been accustomed to living in buildings only two stories high at the most, maintaining close contact with the earth. Thus the recent tendency to accentuate the horizontal rather than the vertical in contemporary architecture seems to represent a return to the feeling and the tastes of traditional Japanese architecture, whose history extends far back beyond that of the modern period.

In the nine-story Kagawa Prefectural Government Building (Fig. 99), designed by Kenzo Tange, the platform floor surrounding each story (except the first) is supported by a row of evenly spaced timbers arranged in the same way that the rafters are aligned in the pagodas of Buddhist temples (Fig. 98). This idea must have occurred quite naturally to the architect, since he chose the same sort of

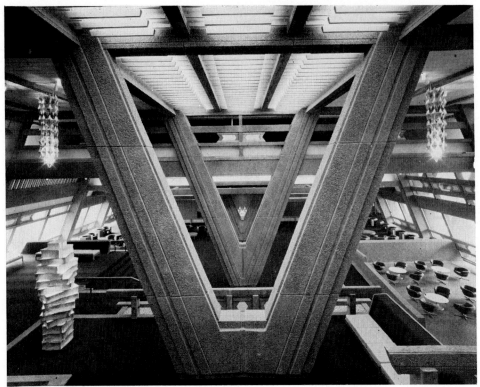

100. *Yukio Otani: V-shaped interior supports, Kyoto International Conference Hall, Kyoto. 1966.*

structure for his own wide, oblong two-story resi-
dence, which resembles a silkworm-raising house,
the first floor being designed for storage. Here, too,
the rafter ends are clearly exposed under the eaves.
If we take the contemporary trend in Japanese
architecture into consideration, we can surmise
that this could not have been simply a question of
Tange's own individual taste.

THE ETHNIC WITHIN It often happens that
THE ABSTRACT the more abstract tech-
niques an artist adopts,
the more explicitly do the folkways that are rooted
in him and the national elements that envelop and
permeate him come to new life in his work. The
neoplasticism of Mondrian displays the same kind
of clean, ordered canvas that we see in the works

of Ruisdael and Vermeer or, for that matter, in the
cool and well-organized paintings by artists of the
contemporary Dutch school of realism, with the
exception that neoplasticism presents the most for-
malized appearance of all. And it is not merely
fancy that in the abstraction of Kandinsky, with
its characteristic emotional expressionism, there
can be felt a blood relationship, so to speak, to the
sweet, fantastic, and sadly lyrical effect of the works
of Marc Chagall. Kandinsky's multicolored overall
effect, with faded but observable madder-red hues,
gives much the same feeling as the Slavic icons of
the Orthodox Eastern Church, with their darkish
browns that seem to hide a yearning to be gold.

As in Japan, painters in Russia struggled to learn
and master modern techniques of painting. Paints
were spread in successive layers across the canvas

101. Kiyonori Kikutake: Hotel Tokoen, Tottori Prefecture. 1964.

until the subject gradually emerged, but this divisionist method of composition was merely an import from western Europe. In fact, the style of realism brought in from western Europe conquered both nineteenth-century Russia and Meiji-era (1868–1912) Japan, so that, artistically speaking, the two countries appeared to be merely colonies. In Japan this trend was interrupted during the Taisho era (1912–26) by the postimpressionist movement of La Société du Fusain (in Japanese, Fyuzan-kai or Hyuzan-kai), established in 1912 by young painters who dissented from the official canons of Western-style painting. In Russia, where the trend was even stronger, it was demolished by the revolution of 1917. After that, except for the painters who left Russia—for example, Kandinsky, Soutine, Chagall, Zadkine, and Poliakoff—the mainstream of the Russian art world seemed to re-embrace realism, whether informalized in the impressionist manner or stylized in the manner of the old icons. But we need not go further into this subject here.

At first glance, one cannot say that it is his being French that characterizes the abstract paintings of Delaunay, but the paintings impress themselves on the viewer in such a way that, after looking at the works of Manessier, Villon, and other painters representing various modern and contemporary French styles, one would know that they could not possibly have come from any country but France. In his rendering of atmospheric light analyzed and harmoniously fixed to the canvas, Delaunay represents one pole of the tradition that dichotomizes the whole history of French painting: whether to

102. Ryonosuke Shimomura: Abundance. *Oils and watercolor on paper; height, 91 cm.; width, 182 cm.*

concentrate on color or on line and figure. His works exhibit a feather-light orderliness—an indigenously French accomplishment in that it differs from the work of Kandinsky in orderliness and from that of Klee in lightness.

TRADITIONAL ELEMENTS IN CONTEMPORARY JAPANESE ART

This kind of national character is quite clearly seen in the works of certain Japanese abstract painters and sculptors. For example, the various "shapes" in yellow or brown that Takeo Yamaguchi places on a black or near-black ultramarine background (Fig. 11) often give us the feeling of the large beams in old Japanese farmhouses. Again, the shapes of Shu Eguchi's sculptures (Fig. 135) remind us of a Japanese fishing village or the banks of a river in the shadow of a levee close to the sea. We probably cannot classify Keiji Usami as an abstract painter, but it is interesting to note that his paintings call to mind dyed cotton materials drying in the sun, their dyes running as though they had been struck by a sudden shower (Fig. 85).

In the instance of Kaoru Yamaguchi's abstractions of Japanese pastoral scenery, it is possible to think that if these paintings had been done in the diffuse, fragmentary, and yet realistic style of conventional impressionism, what we would see before us would be no more than one aspect or another of present-day Japan in which the image of old Japan would exist only in recollection. And, more than the Japanese scenery, we would undoubtedly be obliged to see paraded before us a wide range of techniques reminiscent of artists like Segantini and Pissarro. The particular landscape depicted on the

103. *Tsunesaku Maeda:* The Birth of Man. *Oils; height, 92 cm.; width, 73 cm. 1963.*

canvas would be easily identified with what may be called the common denominator of Japanese scenes that we have been familiar with, and the only question left for consideration would be that of technique. But the most important problem for the viewer, when he is faced with an attempt like Yamaguchi's to eliminate as much of the residue of reality as possible, becomes the aspects of the artist's mind. Of course, a complete abstraction in the ultimate sense would not allow the admixture of any aspect of the artist's individual character, but for a painting to remain a painting—that is, as long as it is a work wrung out of a man—the opaqueness and imperfection of human nature will never allow a work to consist solely of thorough abstraction or pure extraction of the mind. In this connection, it is instructive to note that the purism advocated by Ozenfant and his associates was merely one of the many nonrepresentationalist styles.

Japanese nonfigurative and nonrepresentational works began to draw international attention chiefly through such *informel* paintings as those of Toshimitsu Imai (Figs. 12, 30)—works that look to us like the outburst of a boisterous dance of many colors on the canvas. The reason for such widespread interest seems to be that Westerners saw in these paintings both a denial of national character (a denial toward which they also have an impulse) and a peculiarly Japanese self-contradiction of searching devotedly for minute details within the chaotic. Thus they discovered a significance that they could not find in the *informel* paintings of their own countries.

I have already spoken of the canvases of Yoshishige Saito, with their muddy red, blue, reddish

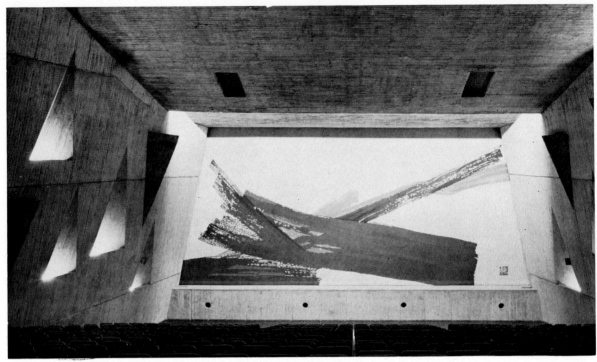

104. Toko Shinoda: stage curtain of Nichinan Cultural Center, Miyazaki Prefecture. 1962.

brown, and green shapes like squashed cocoons filling the entire surface. These *informel* paintings, which were highly praised among art lovers—even by those partial to Chinese-style ink painting and literati painting—display an extremely Japanese character in that they convey no sense of depth and are like patterns dyed into kimono cloth. But even before Saito turned to *informel* painting, the treatment of the outlines of human figures in his caricaturistic works exhibited a style not far removed

from the traditions of Japanese art—a style like that seen in the draftsmanship of such works as the twelfth-century *Scroll of Frolicking Animals and People,* the mid-thirteenth-century picture scroll *The Imperial Guard Cavalry,* and the scroll by Kuwagata Kensai (1764–1824) known as *Pictures of Various Edo-Period Artisans.* But if Saito were a representational artist, it would be something Western, rather than Japanese, in his work that would impress itself upon us.

CHAPTER SEVEN

The Acquisition of Universality

DESPITE MY REMARKS in the preceding chapter, it is a mistake to try to understand abstract painting only through an involvement with tradition. Around 1930, when I decided to have my own style of painting, the style I selected was expressionism. (Since I am not really a professional painter, it may seem presumptuous of me to speak of myself in this way, but because what I have to say here may be useful in recognizing what was happening in Japanese art, I hope I may be permitted this liberty.) I am not really sure how I was motivated toward expressionism, but it must have been through the works of Kandinsky. Recently I had a moment of nostalgia in seeing the same kind of expressionism in Joan Miró's *Balcony, Baja San Pedro,* painted in 1917. The antifigurative and antirepresentational principle that possessed me then, when I was a naturally spirited youngster, manifested itself in a desire to escape from the restrictions imposed on spirit by matter. I conceived of it as something that promised to emerge in my painting as a full-grown nonnationalistic and, as one might therefore expect, international quality. Not being able to deny completely the attractiveness of the colors and figures of realism, I found myself approaching the expressionist technique, which I knew had come from the West, because I could not resist the desire to put on canvas mainly the sensuous surprise I got from the subject I was painting. I remember with pleasure the time when my instructor brought out a picture of mine before the class and said: "How about this? Even though you may not understand it, it looks interesting, doesn't it?"

But rather than listen to an account of myself as a nonprofessional artist, the reader will find it more useful to look back on the activities carried out some seven or eight years after this experience of mine by artists some two to twelve or thirteen years my senior.

PREWAR ABSTRACTIONIST MOVEMENTS

Takachiyo Uemura, a leading art critic, observes: "It was about 1935 that abstract painting clearly appeared as a group movement in Japan. The first major nucleus of the movement was the Free Artists' Association [in Japanese, Jiyu Bijutsu Kyokai], formed in May 1937. At the center of this organization were Rokuro Yabashi, Masanari Murai, Kaoru Yamaguchi, Saburo Hasegawa, Yozo Hamaguchi, and others—artists who had already had a group show in 1934 called the New Epoch Exhibition [Shin Jidai Ten]. Filling out the membership of this group were the members of the Form Exhibition [Forumu Ten], such as Tatsuoki Nambata and other artists who had held a small street exhibition, and the members of the Black Exhibition [Kokushoku Ten], such as Toshinobu Onosato and Tsune Seino."

According to Uemura, in addition to the above members, Tatsuo Arai and Kyu Ei were later re-

105. Ken Hirohata: Dessin. *Watercolor.*

106. Saburo Hasegawa: Metropolitan. *Oils;*
height, 130.3 cm.; width, 162.2 cm. 1936.

ceived as new members, and from July 10 to July 29, 1937, the group invited the public to join in the contribution toward its first exhibition, held at the Japan Art Association (Nihon Bijutsu Kyokai) in Ueno, Tokyo. The works displayed at the exhibition included oils, water colors, drawings, prints, collages, *objets trouvés,* and photographs. Uemura goes on to say: "In Japanese art circles at that time, what was called the 'modern art movement' was still being kept out of the Tokyo Metropolitan Art Museum in Ueno. The artists of the modern school, who were burning with new theories, put great effort into their group street exhibits, partly out of resentment of the mainstream but also partly because they championed the cause of bringing painting into everyday life." Thus Uemura contends that these artists were proud of staying away from the official exhibitions at Ueno. He says: "This shows how limited the influence of modern

art was in those days and how the trends in the Japanese art world were controlled by impressionistic and fauvistic influences. Under these circumstances, it represented an important step in the progress of this country's abstract art movement for the Free Artists' Association to have found at least a small corner in Ueno in which to hold a public exhibit, using the Japan Art Association building."

With Saburo Hasegawa's *Butterfly Tracks* entered in this first exhibit, there was clear evidence that, in individual works, the Japanese abstract art movement showed a fair amount of success from its earliest days. It was evident, too, that a certain amount of groundwork underlay this success. I can remember with pleasure the exhibitions of paintings of the École de Paris artists and their associates held for two or three years running by the Aoki Galleries of Tokyo at the former Tokyo Prefectural

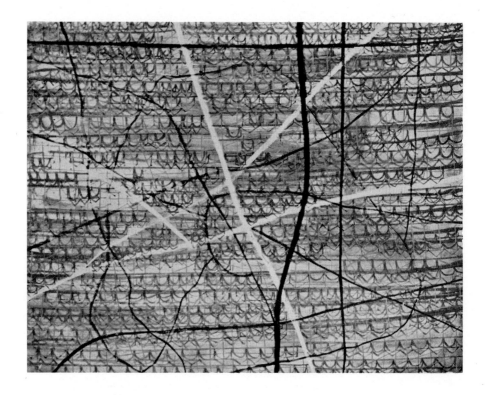

Art Museum (now the Tokyo Metropolitan Museum) in Ueno. I can also remember quite clearly the large number of visitors.

In 1939 the Room Nine Club (Kyushitsu-kai) was formed. This group consisted mainly of artists whose works had been exhibited in Room 9 of the Nika-kai (Second Division Association). The exhibition had centered on works displaying new trends, and the club had many abstract painters among its forty-one members, including Ken Hirohata, Kakuzo Inoue, Takeo Yamaguchi, Yoshishige Saito, Jiro Yoshiwara, Keisuke Yamamoto, Yukiko Katsura, and Uichi Takayama. From the fact that the club had Tsuguharu Fujita (Leonard Foujita) and Seiji Togo as advisers, one can pretty well guess what it thought of the tendencies prevailing in Western-style painting in Japan at that time. The special characteristics of Fujita and Togo were, first, that they showed on canvas, as the essence of a work, a spirit of being the humble servants of color instead of displaying a command of color in the manner of many other Japanese painters and, second, that they produced such a fine texture as never to upset the viewer. While Togo may not be classified with "artists of lines," the two were certainly "artists of form." (This is the point by means of which more than a few painters, such as Chozo Saito and Keiji Shimazaki, try to relate themselves to these two master artists.)

That the Room Nine Club chose these two artists as their advisers symbolizes the desire of the members to follow those among their seniors who found their raison d'être in form rather than in color, which is more vulnerable to the influences of the cultural climate. From this choice, we can surmise the extent of the supranationalism of the Room Nine Club. It must be noted, however, that this is only one aspect of the whole, as one can see from

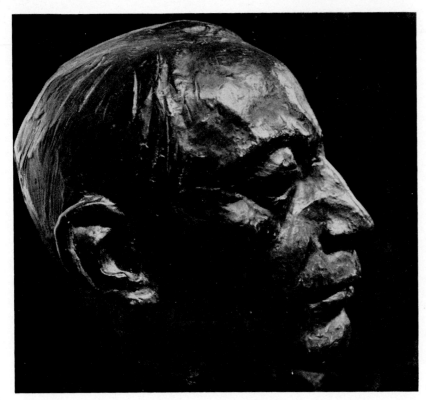

107. Yasutake Funakoshi: Head of Sakutaro Hagiwara. *Bronze; height, 26 cm. 1953.*

the fact that the works of Yukiko Katsura, with their surfaces resembling Japanese textiles stuck to the canvas, and those of Yoshishige Saito, already noted above, can hardly be called supranational.

In subsequent exhibitions, there appeared such artists as Shin Nakamura and Jiro Asazuma, who never showed anything but abstract paintings. Thus we can see that abstract art was not totally fruitless in prewar Japan, even though the situation was inhospitable to this kind of painting during the war. As evidence of the fact that it is an ill wind indeed that blows no good, we have the wartime example of Shunsuke Matsumoto, who until about 1940 painted in a fantastic fashion that showed disassembled town buildings through line drawings of human figures, as in a double-exposure photograph, but who purposely turned to noble and firm realism in order to express anger in quiet,

as it were. We can recognize in Matsumoto's large, organized compositions the same trend that we see in the works of Tsuguharu Fujita. Matsumoto and the sculptor Yasutake Funakoshi, both of whom came from Morioka, in Iwate Prefecture, displayed a highly disciplined spirit, a fresh sensitivity, and a rare and powerful sense of balance. These qualities were so evident in them that the two could be considered representative artists of the prewar antirealist era even if we were to assume hypothetically that Matsumoto would continue as a realist without stepping over into abstractionism, as he later did. This opinion is reinforced by the excellence of Funakoshi's *Head of Sakutaro Hagiwara* (Fig. 107). Indeed, this representation of the influential lyric poet is outstanding not only among postwar Japanese works of sculpture but also among all other postwar Japanese works of art.

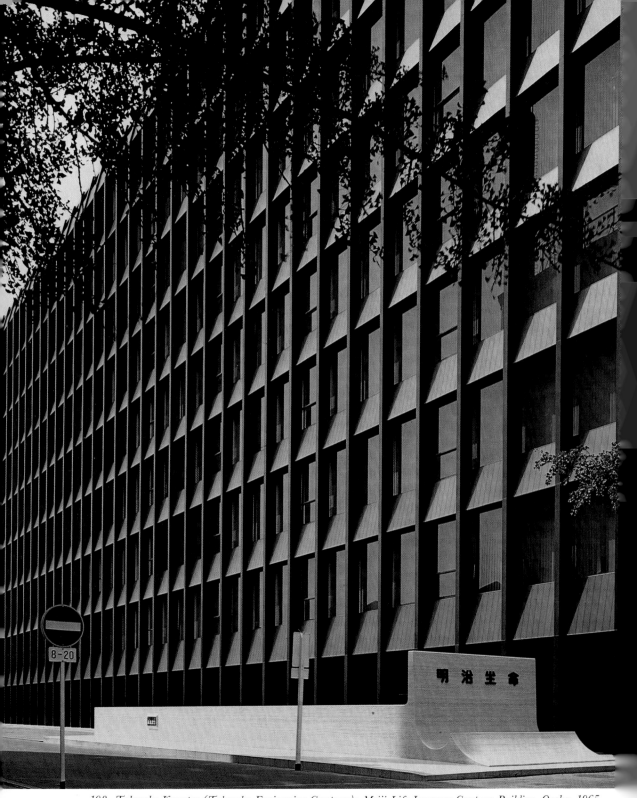

108. Takenaka Komuten (Takenaka Engineering Company): Meiji Life Insurance Company Building, Osaka. 1965.

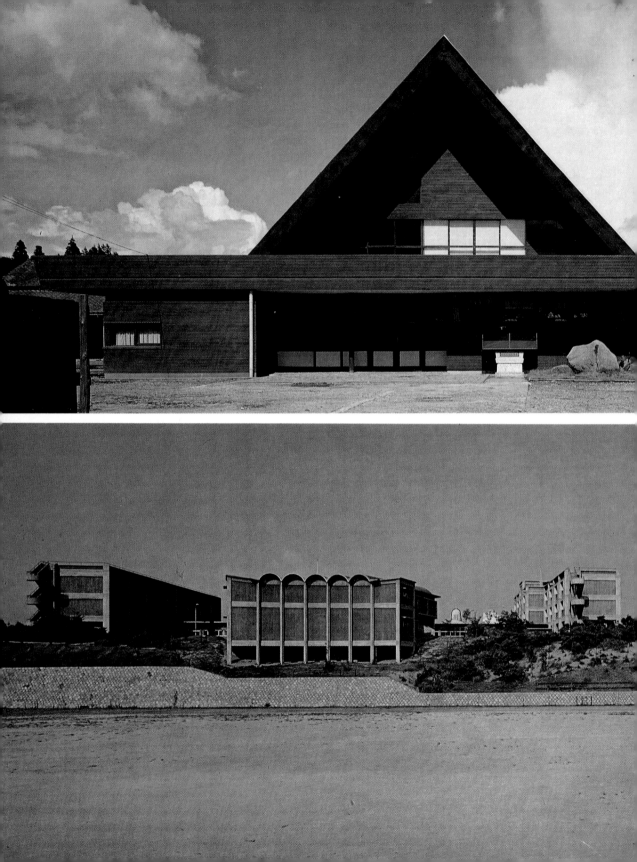

109. Masato Otaka Architectural Designing Office: Kataoka Agricultural Cooperative, Tochigi Prefecture. 1962.

110 (below). Raymond Architectural Designing Office: Nanzan University, Nagoya. 1964.

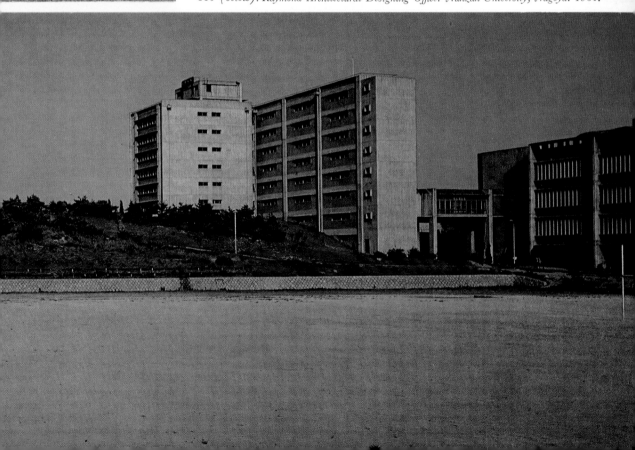

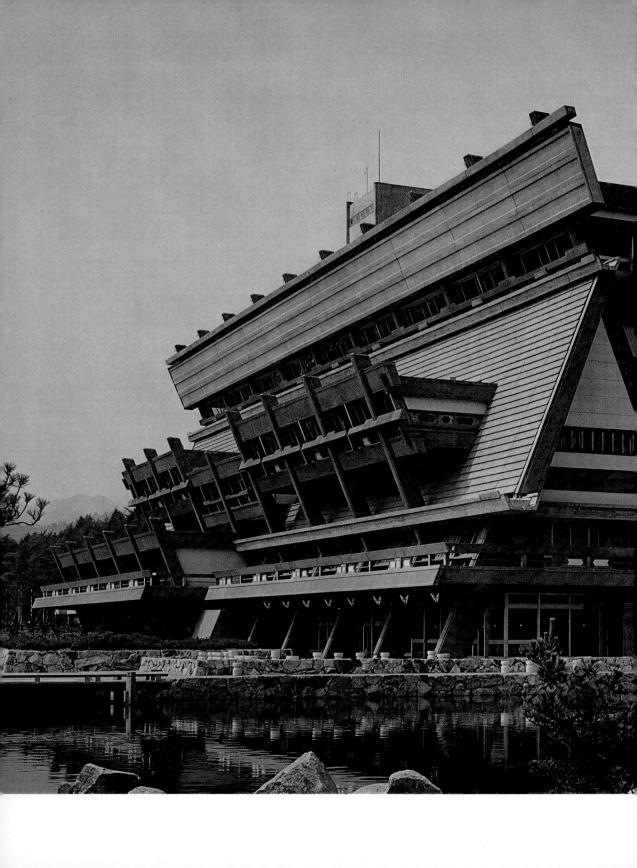

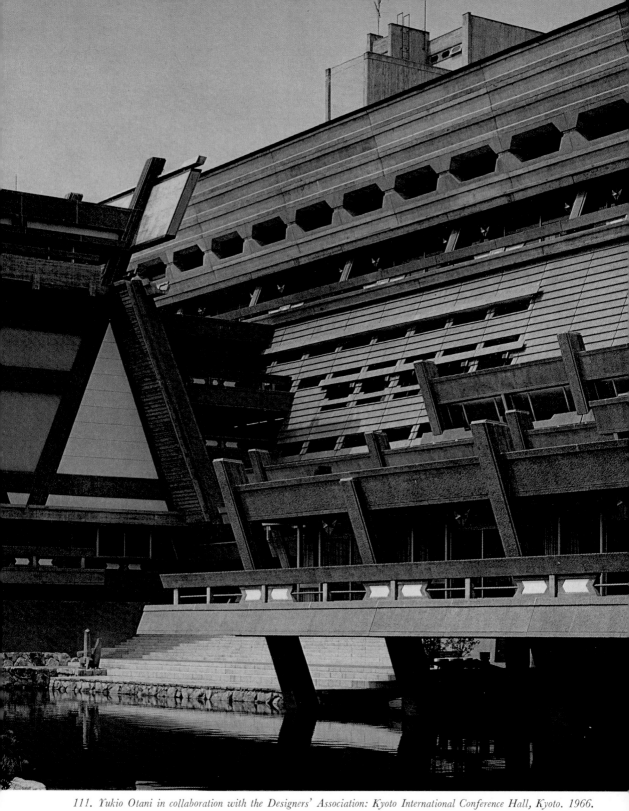

111. Yukio Otani in collaboration with the Designers' Association: Kyoto International Conference Hall, Kyoto. 1966.

112. *Murano and Mori Architectural Designing Office: interior of Nissei Theater, Tokyo. 1964.*

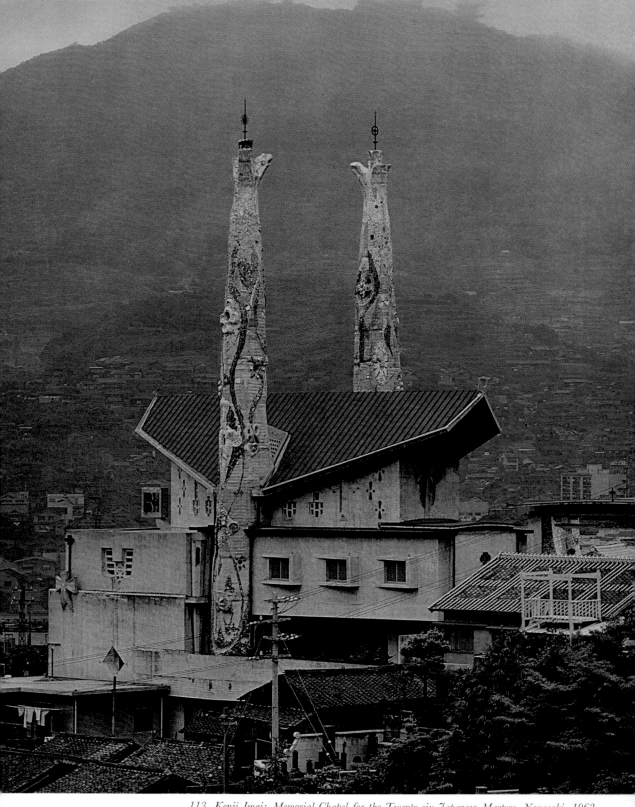

113. Kenji Imai: Memorial Chapel for the Twenty-six Japanese Martyrs, Nagasaki. 1962.

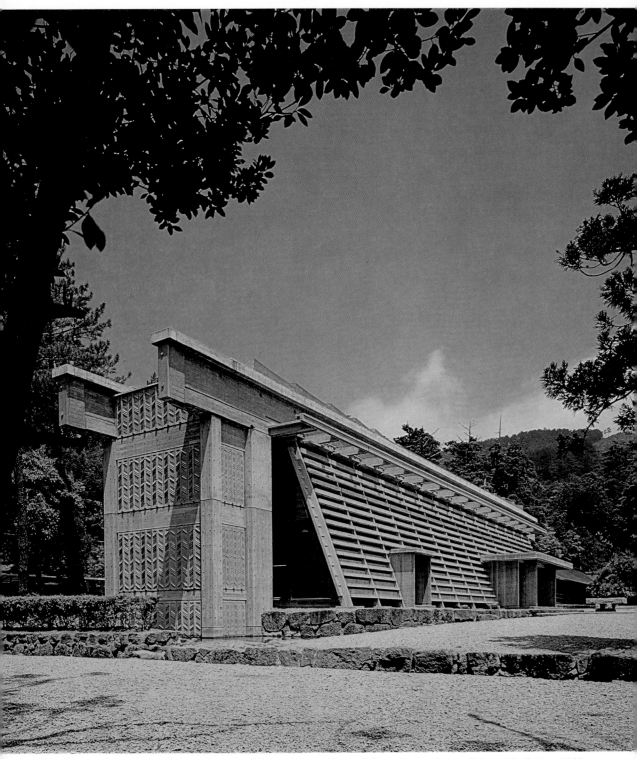

114. Kiyonori Kikutake Architectural Designing Office: Treasure House of Izumo Grand Shrine, Shimane Prefecture. 1963.

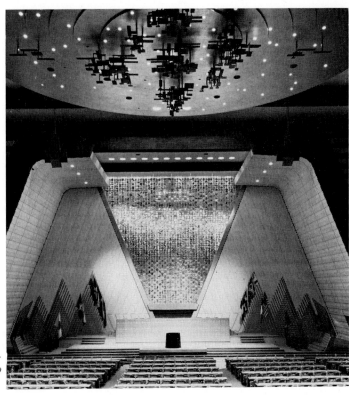

115. Yukio Otani in collaboration with the Designers' Association: main auditorium of Kyoto International Conference Hall, Kyoto. 1966.

POSTWAR ABSTRACTIONISM

World War II subjected Japanese art styles to the same unmerciful disruption as it did the livelihood of the people. We had neither the time nor the inclination to look at pictures and sculpture amid the uproar, the flames, the carnage, and the destruction. Finally, with the end of the war, we were forced to look at works that could not be called anything but effusions of sensuousness, at least in the field of abstraction. There were, for example, the works of Minoru Kawabata and Hajime Minamioji, which showed the social consciousness of the artist through their use of primary colors but at the same time gave one the unsatisfactory feeling of their being merely abstract descriptions of something not clearly set forth. There were also the pictures of Tatsuoki Nambata, which impressed us as being an emotional yet

beautiful expression of the life of a city dweller distressed by loneliness in the midst of sudden urban construction (though it took a little while for his canvases to assume this character). Again, there were the various pictures, or rather designs, of those whose names I need not mention here—works that merely served to irritate the viewer. And there were, among many others, the recent paintings of Kigai Kawaguchi, which demonstrated his abrupt, unconvincing metamorphosis.

Kawaguchi had only lately returned from Wakayama Prefecture, where he had gone to escape the air raids, and the sudden transformation of his painting style caused much wonder. On witnessing the new trends in postwar European painting at the 1952 First Japan International Art Exhibition in Tokyo, he said, his inclination toward avant-garde art, implanted in his mind when he was in

dominate their era. This is true not only of weak-willed, easily influenced Japanese artists but of European artists as well. In Europe, from the baroque period on, stereotyped pictures were invariably produced in great numbers during any given period.

In the establishment of any particular school of art, there is always more or less a correlation between its style and the world view that determines it. Both the Jansenist Pascal and the Jesuits were influenced by the baroque-period view of the world, which saw reality in variations and fanciful ideas. This anti-Reformational ideology was so comprehensive that it not only embraced the whole art world but also provided the driving force for what might be called the pictorialization of architecture and sculpture. It made possible those strong shadows in Caravaggio's paintings that bring drama even to still life. It also made possible, in his scene of the Nativity, the concept that makes us seem to see there an unmarried village girl who has just given birth to a child. Again, it is this same ideology that explains why Rembrandt left portraits of himself and his wife in a variety of costumes and, at the same time, helps us to understand the origin of opera and the fad for garden fountains, as well.

The effeminacy of rococo forms and the omens of the collapse of the Bourbon monarchy were interrelated, as were the historical themes of Jacques-Louis David's painting and the evolution of the idea of democracy. Nineteenth-century positivism and impressionism were inseparably connected in that they relegated the concept of "substance" to a mere parenthesis. There is also an undeniable relationship between the development of various schools of art before and after World War I and the awareness and actualization of Europe's impending internal contradictions.

Until the end of the Edo period (1603–1868) in Japan, painting was one of the few professions that a man could choose voluntarily, but once he be-

Paris thirty years earlier, had suddenly been resurrected. It is worthwhile to note that this remark was quoted here and there with a certain amount of surprise. The statement is far from sufficient for us to use in explaining the significance of his course —from his prewar musiclike fantasies of red, purple, and yellow figures that seemed to dissolve in undulating currents of air, through his still lifes painted in Wakayama during the war, to his postwar abstractions—but it is nevertheless worthy of comment because it pointed out that the real problem with Japanese artists was the lack of a flexible mind with regard to the supranationality of abstractionism.

ERAS AND STYLES Artists are in general extremely sensitive to the style of the school of art that gradually comes to

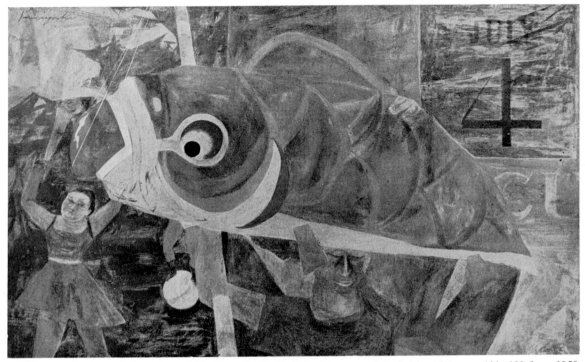

117. *Yasuo Kuniyoshi:* Carp Streamer. *Oils; height, 76.2 cm.; width, 129.6 cm. 1950.*

came an artist he entered into an unchangeable occupation, coming under the protection and, to some extent, the control of the feudal government. Art was not a free occupation. When we compare the Japanese literati painters (*bunjingaka*) of the Edo period with their counterparts and models the Chinese literati painters, who deliberately withdrew from government office and uncompromisingly resisted the new authorities at the changeover from the Yuan (1260–1368) to the Ming (1368–1644) dynasty and again at the changeover from the Ming to the Ch'ing (1644–1912) dynasty, we are led to wonder what it was that the former were protesting against or escaping from. I used to think that perhaps their opponents were primarily the artists of the academic Kano school, who attempted to integrate but in fact vulgarized the techniques of various schools by accepting, in the capacity of

official artists, the patronage of the Tokugawa shogunate, and, in the second place, the much weaker artists of the purist *yamato-e* (native Japanese painting) school, which still survived. (Or rather, since the "courtly tastes" represented and pictorially embodied by the *yamato-e* painters were kept alive by the cultural ideology of the shogunate, it may be said that the artists themselves were kept alive in consequence.) But since the literati painter was not a free agent, just as the samurai was not, and was merely another member of another social class instead, I now think that it was this social hierarchy that the Edo-period literati painters identified as their enemy and therefore opposed, although only quietly and passively.

Because this was the situation in Japan, sensitivity to the styles of their contemporaries was hardly a relevant matter among professional paint-

118. Shigeo Ishii: État de Siège. *Oils; height, 91 cm.; width, 116.8 cm. 1956.*

ers. It can be said that they were all dominated by one technique and even controlled by one model —so much so that nothing can be argued without reference to literati painting. In fact, the sudden birth and spread of literati painting itself can be viewed as supporting evidence for this theory.

Edo-period literati painting had an ethical and social character that tended to make social order, rather than a philosophical awareness of existence, the question of the day. But instead of undergoing a reform in the succeeding Meiji era, when many social and economic reforms were carried out, this tendency was strengthened, and artists became more and more concerned with social and practical considerations. By means of an eclecticism that embraced both Western and traditional Japanese art, they turned themselves into artisans for the purpose of manifesting the "art of the glorious Meiji reign." As we can see in many of the paintings that survive from this era, the "truth" that the artists purported to portray was nothing more than what we might call pseudonature, still strongly redolent of the "humanity" of the preceding age. Some artists in the first years of the Meiji era were firmly convinced that realism was the road to a new life that would deny the old. Their unshakable faith in this belief is well known to us from the memoirs of the sculptor Koun Takamura and the activities of such artists as the Western-style painter Yuichi Takahashi. Still, what we see in their works is the reflection of a society and the physiognomy of an era rather than the central truth of the subjects they depicted.

In this respect, all the artists of the early Meiji era resembled one another. The reason for this is that before they could develop any manner of ex-

119. *Ushio Shinohara:* The Emperor and Empress Dolls of the Doll Festival. *Fluorescent paints on plastic; height, 1.8 m.; breadth, 3.6 m.; depth, 3.6 m. 1966.*

pressing their individuality, all they could do was to learn the prescribed techniques of putting down what they believed to be a true picture of life. The situation in early Meiji was different from that of a later time when artists still resembled one another despite having by then mastered their techniques. Even though the following Taisho era is said to have been marked by a great respect for individuality, if we were to see an exhibition composed only of works by Taisho artists whom a later age considers "novel," we would be caused to wonder what kind of artists besides these could possibly have existed at that time.

At the basis of this situation was the fact that the Japanese artist, like most other Japanese, rather than stand alone and live in conspicuous contrast with others, elected the easy way of burying himself in the mass. At the same time, there must

have been a different reason for the repeated, frantic transformations in Japanese Western-style painting, which seems to have fluctuated with the various waves of foreign influence. In the first place, the materials used in Western-style art and the philosophies that supported it were originally European, and, like the technical advancements and the schools of thought that are now conquering the world, they can be said to have been universal, since it did not require any specific personality to accept them and put them to use. In the second place, the frequent transformations in Western-style art in Japan resulted from the recurring necessity of supranationalizing the universal terms that had been Japanized as they came in. That is to say, although Japan was too "Japanese," too rich in indigenous characteristics to succumb easily, it was inevitable that Japanese art should

120. Seiji Chokai: Squash and Pitcher. *Oils; height, 75 cm.; width, 62 cm. About 1949.*

121. Morikazu Kumagai: Roses. *Oils; height, 27.3 cm.; width, 39.4 cm. 1962.* ▷

be supranationalized. But it could not be completely internationalized. The problem was that the Japanese themselves were not aware of the limitation stemming directly from their peculiarly Japanese disposition. It lay in the fact that we innocently accepted, as new treasures of great value, any and all imported materials and ideas without making any estimate of the extent to which we were capable of being internationalized.

ART AND ZEITGEIST The critic Teiichi Hijikata recognizes the same Japanese quality in the works of the painter Seiki Kuroda (1866–1924), in the concept of nature held by the poet-novelist Toson Shimazaki (1872–1943), and in the views expressed by the nationalist geographer Shigetaka (also known as Juko) Shiga (1863–1927) in his book *On Japanese Landscape*

(1894). Similar analogies can be found elsewhere. For example, we have the painter Ryusei Kishida (1891–1929) and the novelist-playwright Saneatsu Mushanokoji (1885–), who together can be said to have marked off an epoch in Japanese cultural history. Although their fields are different, their work is characterized by a belief in the unity of goodness and beauty, by a respect for individuality, and by an antinaturalistic and anti-impressionistic point of view.

In the same way, the seemingly abrupt transformation of postwar art, resulting in various stylistic ramifications that all rejected the rule of realism and were thus interpenetrable and mutually transformable, may reveal some similarity when it is compared with the change in literature after the first so-called postwar generation. Most fundamental in this respect is the reflection in art (and

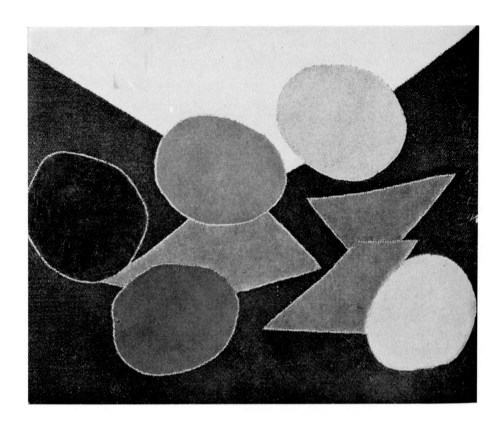

in other forms of expressive activity) of the obliteration in postwar Japan of rigorously organized social institutions and disciplines. In spite of a violent reaction against idealism, there was a strong flavor of subjectivism. But the subjectivity of a painting was not regarded as a projection of the artist's mind, as in expressionism. Instead, the work was totally divorced from the artist's internal world and was intended to stand in its own right. On the other hand, the people who were used on the canvas as subjects for expressing the artist's subjectivity came to have only an abstract meaning and lost their actual existence. The decline of the "transformed but real images" of Chozaburo Inoue and Masao Tsuruoka and the flourishing of the abstract style, therefore, seem to correspond to the transition in literature from the styles of Yutaka Haniya, Taijun Takeda, and Hiroshi Noma (the so-called

first postwar generation) to those of Kobo Abè and Yoshie Hotta.

Is the next dominant style in literature *informel* then? It would be rather useless to speculate, for it is only in revolutionary or epoch-making times that fundamental agreement in the thought underlying various arts can be found.

Perhaps these points can be best illustrated by looking through the pages of the collected paintings of Shunsuke Matsumoto, which seem to support wordlessly what I have said above. As if resisting the tide of the prewar era, Matsumoto abandoned his older style and turned to the painting of ostensibly realistic pictures in which, to prove that the changeover had been deliberate, he expressed a sense of cleanliness and tension. After the war, around 1947, he presented his *Man,* a painting in reddish-brown tones and black lines that was al-

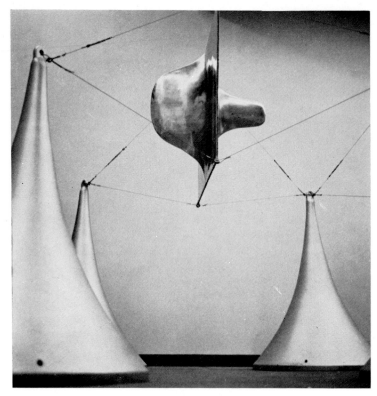

122. *Morio Shinoda:* Tension and Compression. *Bronze; height, 110 cm. 1966.*

most a perfect work of abstraction. In the meantime, especially from around 1944 to around 1946, he produced sketches in which he graphically portrayed the destruction brought on by the war. Thus he accomplished three transformations of his painting style, and it is because he has struggled to determine his style through these transformations that his abstractions seem so valid today.

In a different world, and of a completely different temperament from that of Matsumoto, there is Seiji Chokai. Around 1949, Chokai repeatedly produced still lifes in which he combined stylized squashes of dark and rustic tone with brightly glowing lemons to create the effect of musical notes. Whether these paintings represented a challenge to reality or faithful obedience to it, they demonstrated a way of escaping from the trend of recent painting, in which the restrictions of reality

were being displayed in various forms. Later, in the series known as *Terraced Rice Fields,* he reached what was considered to be a new peak of achievement. In addition to the inner conviction on which his paintings were based, there must have been another reason—a reason related to the world and the times—why this nondescriptivist painter, who had never attempted to produce anything that could be used as an encyclopedia illustration, received such plaudits after the war.

In a similar way, Morikazu Kumagai, who is probably the oldest artist to be considered in this book, changed his style after the war from what might be called a Japanese-style fauvism—using dull, dark-yellow and cobalt-blue tones—to a somewhat decorative style in which he created joyful compositions made up of simple forms circled by vermilion lines (Fig. 121) that are reminiscent

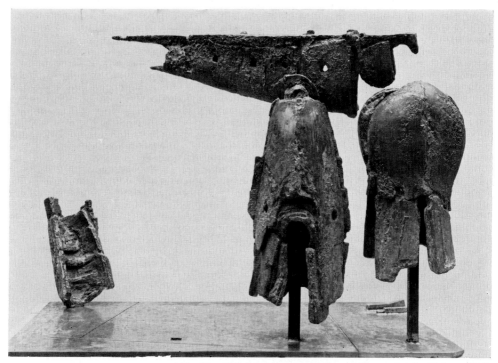

123. *Munehide Hosokawa: untitled work. Bronze; height, 110 cm. 1966.*

of the works of Matisse, who had gone so far as to make collages of cut-out paper. It is hardly an exaggeration to say that here Kumagai shows us a universal method of painting that brings to light the real self so stubbornly guarded within the personality.

UNIVERSALITY
ACHIEVED

The development of the method of simplification through which these older Japanese artists intended to express their will coincided with the trend in the rest of the world. No such unity had been seen since the last years of the Edo period, when the Japanese art trend of approaching realism and dealing with familiar subjects coincided with a similar trend in Western painting of about the same period. After this, however, the Japanese came under the yoke of excessive national con-

sciousness. It is worth repeating that the attainment of universality is undoubtedly the salient characteristic of postwar painting, and whether he likes it or not, the painter must fight his battles and win his fame in the universal arena. It would be well to remember that, figuratively speaking, the walls of the exhibition hall have stretched to embrace the whole world, and the terms and concepts of art belong to a universal language, so that no longer is anyone surprised at simple novelty or a pretty veneer.

Willingly or not, artists are once again charged with the responsibility of devising means to express their individuality. Perhaps Tomio Miki's *Ears* (Fig. 136) is an attempt to answer this current problem. And what is the significance of Jiro Takamatsu's shadows in his *Identification* (Fig. 140) and of works like the previously mentioned outsize can-

124. *Yoko Shigenobu:* Untitled Work. *Oils; height, 180 cm.; width, 180 cm.*
1964.

vases of Ushio Shinohara with block-print effects?

Among the paintings of Yoko Shigenobu labeled *Untitled Work* there are canvases filled with countless vertical and horizontal rows of dots painted with small brushes, giving the effect of an assemblage of wriggling insects in red, yellow, purple, and gold on a reddish-toned background or in blue, black, green, and white on a bluish-toned background (Fig. 124). Those who always assume the existence of a Western model for any present-day Japanese work would probably consider these paintings to be in the style of Mark Tobey's "white writing," but it would be hard to deny that Shigenobu's work represents a new kind of traditional Japanese painting incorporating superior elements taken from the art of pattern drawing and dyeing as done by traditional Japanese craftsmen. This estimate, however, may not be to the satisfaction of the painter herself, who, incidentally, has been an exhibitor at the National Art Association (Koku-ga-kai). In any case, her paintings, rather than being the medium for depicting a subject, are seen only for themselves in the same way in which dyed textiles are appreciated. This quality is none other than what makes them examples of contemporary art.

Has the contemporary artist somehow remembered that it is only through acquiring concreteness that he can find an answer to the problem of recovering his identity in the world? Or can this problem be solved only by having one's own forte, as displayed in such Edo-period works as Ito Jakuchu's paintings of chickens and Mori Sosen's paintings of monkeys?

CHAPTER EIGHT

The Disintegration of Sculpture

THE DIVORCE FROM THE HUMAN FIGURE I have already pointed out that contemporary sculpture does not have the power to hold the viewer before it for a few moments of contemplation. One reason for this failure to attract prolonged attention is that sculpture has turned more and more away from its major traditional theme: the human figure. Even sculpture that still employs the human figure as a subject has made it unrecognizable through extreme distortion and transfiguration. There is probably nothing that calls out to people with such concrete force as the human body—not the abstract concept of man, but the flesh-and-blood body itself. The beauty, the poverty, the strength of man —these are the attributes that touch and capture our hearts when they are given form. But the human form has been abandoned as a subject in contemporary sculpture. That is to say, the representation of the human figure has been precluded from the purposes of sculpture.

Until recently, every school of *déformation* since the cubists has been rather timid with regard to the treatment of the human face. Even in the works of Picasso and Dubuffet, for example, the face is painted in such a way as to retain its features and to be identifiable as a face, no matter how strange it may appear. It is indeed true that man, especially his face, has a peculiar power of fascinating and dominating the artist's mind. As for those artists who disliked the idea of vulgar realism involved in painting actual facial features and therefore painted blank and rather uniform egglike shapes instead, we can say that even they were unable to overcome this special power of charm and domination inherent in the human face.

Now, however, it appears that sculpture has learned to divorce itself resolutely from the human figure. While it is true that there are artists like Yasutake Funakoshi and Tadayoshi Sato who have proved themselves as sculptors with their representational human figures and busts, as well as artists like Masaru Kinouchi who have gained recognition with their grotesquely exaggerated fleshy nudes, and that the world of contemporary sculpture would be unbalanced and rather desolate without such artists, it is nevertheless undeniably true that other sculptors have firmly rejected the representation of human figures as such.

Does this rejection result from a feeling of helplessness? This is a crucial question, and the answer is both no and yes. The reason for the negative answer is that no contemporary sculptor considers himself incompetent, nor does he have any feeling of incompetence in relation to representational sculpture. The question can be answered affirmatively because the sculptor, possessed of a view of man, history, and the world in which the master of man is not himself but rather some system or mechanism, has come to regard it as his mission to produce *objets*—that is, works like mechanical contrivances or meaningless "pure forms" quite un-

125. Jean Tinguely: Barbarian (Totem No. 2). *Various metals. 1960.*

related to man. What is implied here is that the sculptor has surrendered to a view of history and society based on the theory of human alienation. That is to say, the sculptor is aware of a powerlessness not necessarily of his own but of contemporary man, whose image it is his mission to express.

THE PLACE OF SCULPTURE IN MASS SOCIETY

The contemporary sculptor seems to be working outside the sphere of everyday life. It is difficult to say in a word what the guiding principle of contemporary everyday life is. In fact, it can appropriately be said that one of the characteristics of the present-day world is that guiding principles have lost their ability to guide. We can say that after the masses (Paul Valéry's "ants") have passed through the phase of existentialism, wherein each becomes aware of his own existence,

his powerlessness, and the motive underlying the dissatisfaction and rebellion that seethe inside him and, at the same time, comes to possess the means of expressing this awareness, the strength of fellow feeling declines in spite of, or perhaps because of, the growing number of people who have attained such awareness. At this stage, when it becomes less painful for one person to be like another, there develops what might be called a cheerful self-contempt. In a word, people have come to make light of themselves and are quite happy about the way they are.

Is this the principle that guides contemporary everyday life? No, it is a mode of life rather than a principle. The principle is something more basic —something that has given rise to the mode of life. It is the mechanism of production that is responsible for this mode of life, but the mechanism is no longer controlled, as it was in the past, by a few individuals whose names were destined to be remembered over long periods of time. Instead, what is remembered today is the names of the agents or representatives of the mechanism or those of the variety of showy consumer goods that the mechanism produces in this age of mass consumption. The individual is becoming more and more anonymous, and it is this blessed anonymity that functions as the guiding principle of the times. In fact, the times are such that, while the names of the astronauts are internationally known, the names of the people who built the space capsules and satellites are remembered only by those in the aerospace industry. And, while the names of the actors are known, no one even tries to learn the name of the playwright or the scenario writer.

There are no more heroes. As the spirit of hero worship tends more and more to subside, except when it is purposely stirred up, even the politicians have climbed on the mass-media bandwagon. And even the research worker engaged in the improvement of production techniques is no longer a lone sufferer but a white-collar worker envious of another company equipped with better research facilities.

Sculpture, having been born for the most part out of a need to honor gods and heroes, is naturally

at a loss to find a place for itself in the present age of rapid social and economic change. The anonymous individual in contemporary society, who is indistinguishable from others and has no particular desire to be different, can neither be used as a model nor be considered a hero worthy of being honored. For this reason, it is extremely difficult for sculpture to find the way ahead—that is, as long as it aims to represent human figures—except by copying the external appearance, the empty shell, of the man who has lost his identity through being submerged in contemporary civilization. The road that is taken, then, leads to the production of people's heads in the shape of eggs, as in the work of Brancusi, or of group sculptures of stylized figures that resemble screens or shields, as in the work of Zadkine. Tinguely attempts to keep the momentum in discarded machinery (Fig. 125), while Gabo and Pevsner employ densely stretched threads to create sculptures that suggest the inside of a machine or a model for the study of physics. Manzù produces outwardly representational human figures that are actually so unhuman as to be symbolic of the present state of man. Crippa constructs objects of polished odds and ends that seem to have been gathered from a metalwork plant. Giacometti contrives statues that suggest the very last shape of a human body from which the flesh has been gradually stripped away, as though to leave a symbol of the essence of man. I do not include here the unpleasantly coquettish nudes of Emilio Greco, for I consider them to be dolls rather than works of sculpture.

Although there are still sculptors like Henry Moore who create monumental works, sculpture in general presents us with ironical imitations of the mere shell of human existence or, if the human figure is its theme, with the reduction of that figure to nothing more than a substance. As a result, we have reached the point where it is permissible to give the name of sculpture to works that simply jut out from the surface of a wall. Katsuhiro Yamaguchi, who earlier created the totally meaningless but pleasant effect of colored lights playing on a wavy sheet of glass from behind, moved on to create wall hangings designed purely for amusement.

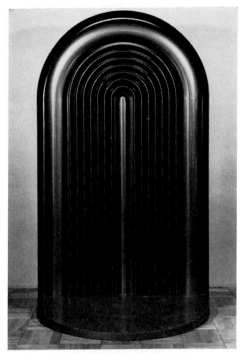

126. Tomio Miki: Work. *Metallic paint on wood. 1966.*

These were made by pasting pieces of old cloth, dyed with various colors and inscribed with characters, on frames of different shapes like those of bamboo or sedge hats, centipede kites, and other objects—some of them quite strange and indescribable. There are perhaps two reasons why these works in cloth, with their fine inner frames, are much more truly sculpture than many recent works done in metal or stone: first, their spatial composition, created by their tensile frames; second, their display of a kind of warmth rooted in the everyday life that is familiar to the viewer.

One of the works of Ryokichi Mukai, which he named *The Victor's Chair* (Fig. 134), has a back with shiny circular decorations, a seat with spiky and blunt protrusions that would be impossible to sit upon, and broken and jagged armrests that would be painful to the elbows. But rather than being directed by these features toward an understand-

ing of the meaning of the title, our attention is focused on the fact that the artist has made a chair with no one sitting on it. It is this latter point that we recognize as having a significance for the times. Briefly, the primary meaning of the work lies in the emptiness that the artist has created. It is only of secondary importance that this emptiness overcomes any implication of sarcasm. Similarly, although Shu Eguchi's sculptures in wood (Fig. 135) take us back to the familiar beaches of our land, we cannot help noticing, when we get there, that there is absolutely no one around.

All traditional sculpture, at the same time that it draws our attention to itself as an entity, leads the eye along its irregular surfaces and into the surrounding space, so that, as a rule, the coexistence of sculpture and space creates a subtle symphonic effect. But Tomio Miki's *Ears* (Fig. 136), in a very unsculpturelike way, tries to keep us from seeing anything but itself, just as a single-panel standing screen does. For this reason, in spite of its being a three-dimensional work, I consider it to be a picture rather than a work of sculpture. In fact, one of Miki's more recent works confirms this tendency of his. Entitled simply *Work* (Fig. 126), it is made of pine sprayed with metallic paint. Essentially it is a series of concentric inverted U shapes molded into a pattern of ridges and troughs, and it looks just right for a decorative screen at the end of a long hallway.

The relief sculptor achieves at best only an incomplete three-dimensionality in his work, but as a result of his efforts to create an atmosphere in the flat background of his projecting figures, the figures themselves give the illusion of being three-dimensional. In fact, to fulfill his purpose, the sculptor makes no clear line indicating the boundary between the projecting images and their base, and the base itself always remains vague and obscure. It is for this reason that relief carving, as a whole, takes on a light feeling. When it does not, it is loud and arid, like the carved wooden transoms of the Edo period, and becomes nothing more than artifice.

Since Miki's work is not relief, it does not have the unpleasant, showy character of Edo-period

carving. At the same time, it has neither the light feeling that we have just noted nor the quality of stability along the vertical dimension that gives rest to the mind and is found in all sculpture worthy of the name.

MOBILES What about the genre of art known as mobiles, of which many superior examples have appeared in our time? Is it sculpture? If sculpture is to be understood as the three-dimensional art that affords pleasure to the sense of touch, that lifts itself (while in this material world things tend to settle into a mass when they stop moving), and that gives us the pleasant feeling of height, through which it offers wordless testimony to the victory of man's work, then mobiles cannot be regarded as sculpture. But if we conceive of sculpture as creating a feeling of the liberation of our spirits through unforeseeable simultaneous multidirectional movements generated by a stream of air set in motion by the viewer, as if it had been set free of the universal law of gravity, we cannot help considering the mobile as a new form of sculpture.

It is unfortunate that in Japan, a country that has traditionally respected the quality of lightness, there has not been a master of the mobile genre, which, through its ability to escape the force of the laws governing normal substances, transcends the tendency to obey the strictures of logic and rationality—in short, the art that, even in the everyday environment, dispels the everydayness of life. Still, we have such works as a mobile by Minami Tada consisting of a highly polished and irregularly bent thin metal plate that resembles a crushed frying pan suspended in midair. Although the heaviness of its movement leaves something to be desired, it offers the pleasure of incessant and complex changes of form and color made by the warped reflections of the faces and figures of the viewers and the surrounding objects. These rich reflections have the power of drawing the viewer into a world comprising only himself and the work—a world where he is caused to meditate upon the contemporary age by way of his sensuous impressions. The concept here is different from that of traditional sculpture,

127. Katsuhiro Yamaguchi: Vitrine 50. *Plastic; height, 95 cm.; width, 65 cm. 1966.*

approach the state of being sculpture? Or is it really that they are sculpture trying to escape being sculpture? I myself think the first question is the one more relevant to the facts, but "from what direction" is not so easy to determine.

Sculpture originated when man was inspired to make with his own hands images of men and animals that he believed to have transcendental qualities. In this respect, the new category of sculpture that we are considering here is of the same nature as sculpture in general and is indeed, far more realistically than ordinary sculpture, a product of the desire to imitate.

Suggestions for this type of sculpture can come from innumerable sources: a fallen leaf clinging to an invisible cobweb and revolving while suspended in space; raindrops on a windowpane drawn toward one another and making a pattern of vertical and diagonal lines; the symphony created by the collision of waves on the moving surface of water and the accompanying obliteration and return of reflection; sheets on a clothesline billowing in the wind; polished wooden boards reflecting distorted images unexpected in the midst of civilized life; a heavy object accidentally in equilibrium like a balancing toy; objects like gliders that can be interestingly imitated in art even though they themselves are not made for artistic purposes; objects made by fanciful show-window decorators or capricious glass-plant workers; and so on.

Lost among such things, the artist can attempt to imitate them creatively, and it is out of such imitation that the type of sculpture we have been considering here is born. Works like these are not necessarily produced with the intention of creating sculpture, and even if they are not sculpture, it is nothing to raise an objection against. The materials for such works, although carefully sought out and highly prized, are not those of sculpture in the traditional sense, and their sculptural effects are only visual and no more than a mirage. Katsuhiro Yamaguchi's later style (although it should be noted that his style may change at any moment), displayed in a work exhibited at the same show that included Tomio Miki's above-noted creation of pine sprayed with metallic paint, indicates quite

for this work of art, instead of making us search for a meaning, spontaneously tosses at our unthinking minds something that we may take for a meaning. It seems to invite us into a dialogue with the three-dimensional world that it has created, and, as a result of making us aware of being tied to it by our own line of vision, it has the power to capture us and make us walk at least halfway around it, though perhaps not all the way. To this extent, it has nearly the same effect as sculpture. The sense of liberation of the spirit that we encounter here helps to confirm this impression.

CREATIVITY IN IMITATION If it is permissible to assume the viewpoint that Katsuhiro Yamaguchi's *Vitrine 50* (Fig. 127) and his cloth-and-frame constructions and Minami Tada's mobiles and panel constructions (Fig. 56) of crushed or corrugated sheet aluminum are sculpture, then from what direction did they

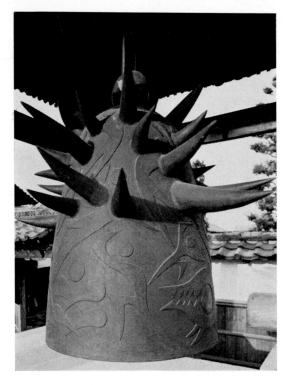

128. *Taro Okamoto: bell for Kyukoku-ji temple, Nagoya. Bronze; height, 1.5 m. 1965.*

clearly, as does his *Vitrine 50,* that the life of his works lies in their mirage effect. In this particular work of Yamaguchi's, a transparent plastic pipe, bent like a shrimp shell and resembling a large caterpillar, climbs a transparent plastic box that contains a rotating red lantern.

THE APPROACH Even an artist like Yoshiaki
OF SCULPTURE Tono finds it difficult to say
TO DESIGN whether his own works are "sculpture" or "designed solids." Regardless of whether they are approaching sculpture or escaping from it, they most certainly blur and erase the borderlines between art genres.

In contemporary art we have pictures like photographs of models for a machine, drawn with ruling pens, compasses, and rulers and then mechanically enlarged. There are also the creations of op art, with their infinite regular repetition of a unit figure —the kind of pictures that lead the viewer into hallucinations. These too are in the process of erasing the distinction between artistic painting and mechanical drawing and pattern designing.

Pictures employing colored tiles have been in existence since ancient times, when the art of the mosaic first developed, and the genre is hardly a surprising one today. But the makers of the famous Byzantine mosaics, for example, although they had a consciousness of beauty and a desire to create it and, at the same time, possessed both the will and the technique to realize their desire, lacked the awareness of being artists, just as the ancient Japanese sculptors of Buddhist images did. On the other hand, the mosaics of the modern Japanese artist Taro Okamoto are filled with this awareness (Fig. 84), and we can see here the obliteration of the boundary between applied art and pure art. Not only that, however, for here is opened a new path

129. *Takamasa Yoshizaka U Research Institute: seminar center for cooperative use by universities, Hachioji, Tokyo. 1965.*

130. Kenzo Tange Research Institute: Tokyo Plan. *1960.*

131. Interchange at Sekigahara on Nagoya–Kobe Expressway, Gifu Prefecture. 1964.

132. *Noriaki Kurokawa Architectural and Urban Designing Office: rest pavilions, Children's Land, Kanagawa Prefecture.*

133. *Masayuki Nagare: wall decoration and sculpture, Mido Building, Osaka. 1965.* ▷

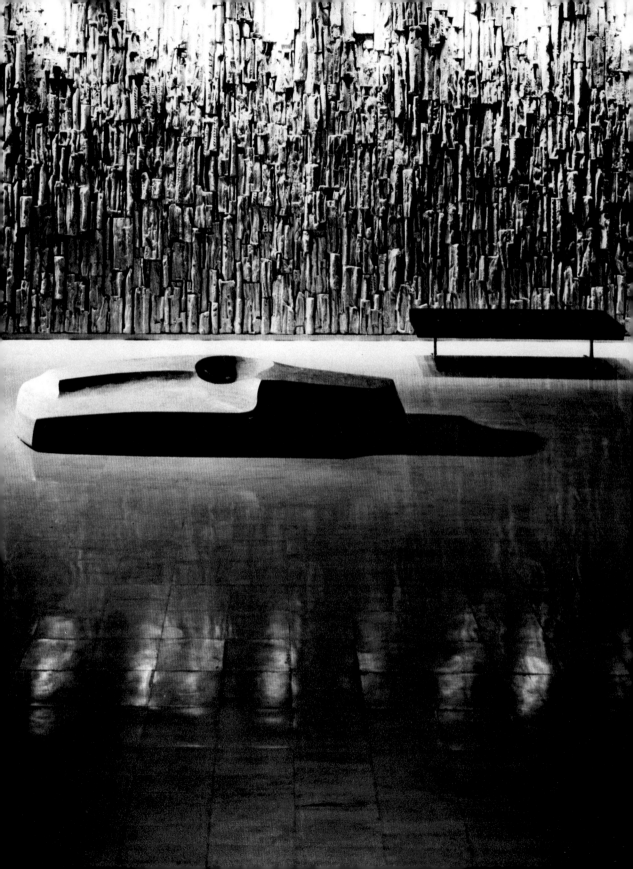

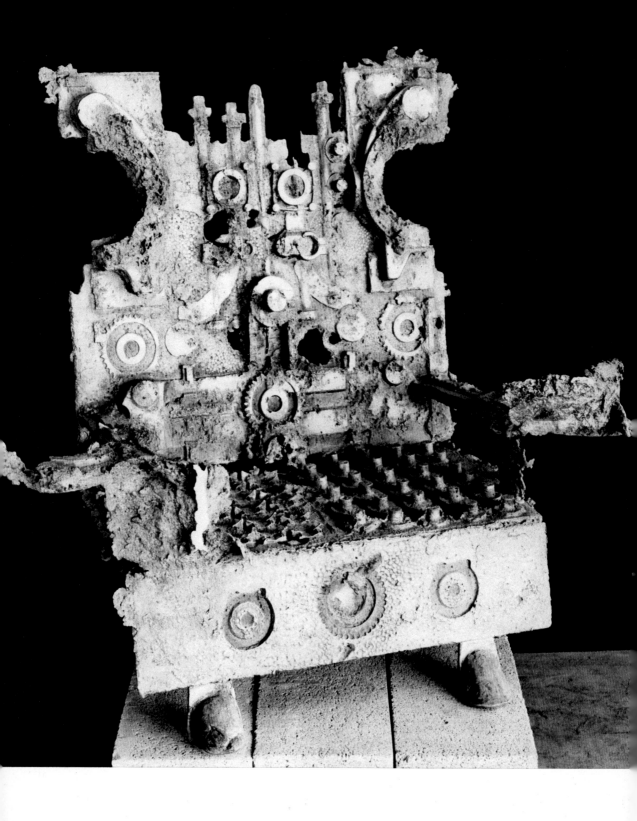

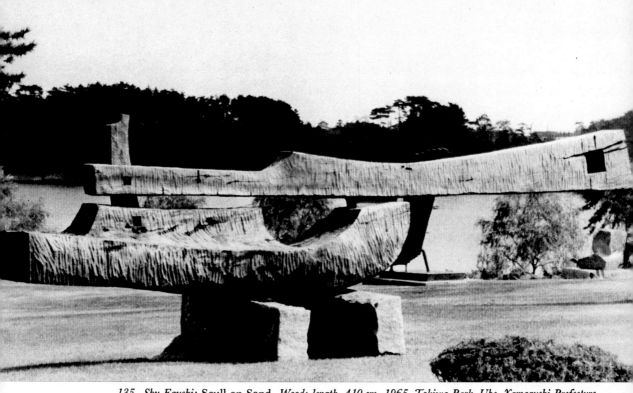

135. Shu Eguchi: Scull on Sand. *Wood; length, 410 cm. 1965. Tokiwa Park, Ube, Yamaguchi Prefecture.*

◁ *134. Ryokichi Mukai:* The Victor's Chair. *Alloy; height, 85 cm. 1964. Kanagawa Prefectural Museum of Modern Art, Kamakura.*

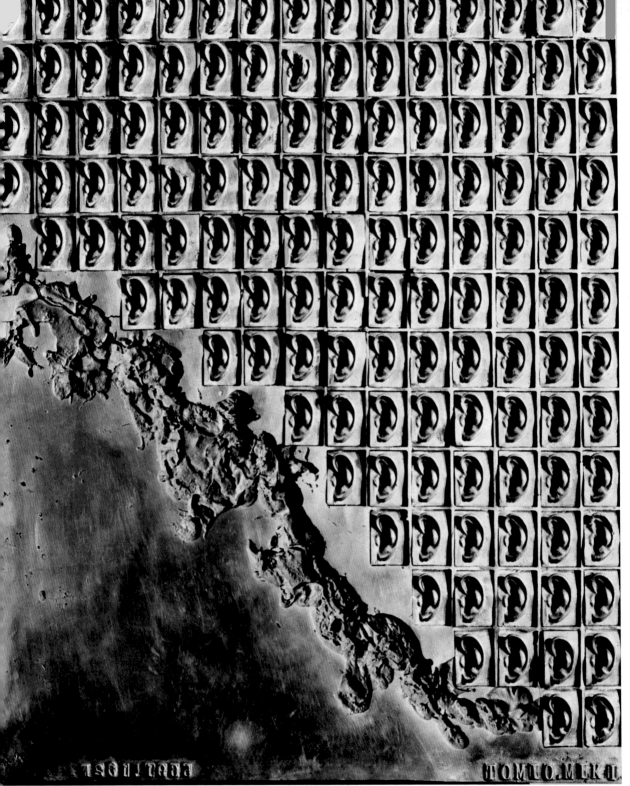

136. Tomio Miki: Ears. *Alloy; height, 105.5 cm.; width, 88 cm. 1965.*

that makes it possible for painting to be produced in the same way that a stonemason builds a stone wall. Or, to view the matter somewhat differently, we can say that we see here an attempt to "architecturalize" painting. In contrast with the Byzantine craftsman, who was expected only to achieve the best artistic effects possible within the rules and conditions laid down by his predetermined subject matter, Okamoto is free to select any subject that strikes his fancy. Therefore we can say that he has chosen to be responsible as the creator of the images he depicts. But this is not all, for he has also made himself responsible for deciding on the colors to be baked into the tiles and for determining the number of tiles needed for each color. Again, he assumes the responsibility for assembling the tiles or having them assembled. Thus he assumes the double role of the designer and the construction chief in architecture.

This kind of activity is not the same, however, as the designing and production of industrial merchandise. The difference lies in the fact that although Okamoto's tile walls could be produced in volume, they are not intended for mass production. The kiln used for baking the tiles, however large and costly it might be, means nothing to him or to the wall after it has once been used. It is as though it no longer existed. And of course it is entirely different in character from the production equipment used for industrial goods. The designer of industrial goods keeps his products under the control of his production equipment, either by designing them in such a way that they can be produced by already existing machinery or by designing machines that can produce them in the desired form. In the case of contemporary mosaics, however, the tiles are produced by exploiting the equipment, and the equipment is abandoned after the work is completed. We can see a resemblance here to the relationship between the sculptor of bronze statues and the equipment that he uses for casting.

The same can be said about Okamoto and his Buddhist temple bell (Fig. 128). In this work the bosses that decorate the upper part of the traditional temple bell have been drawn out into protuberances that resemble water-buffalo horns, and the skirt of the bell displays reliefs in a number of Okamoto's favorite shapes. While he accepted all the essential requirements of a temple bell when he designed this one, he did not follow them slavishly as the ancient bellmaker did. Nor did he try to improve on traditional bellmaking methods. His sine qua non was to make the most of creativity while accepting indispensable conditions. He made the bell as an artist, not as a craftsman.

We cannot consider his bell a sculpture, however, for the reason that as a bell it has, as it must, a hollow shape prescribed for it and imposed upon it. But at least the artist's creativity came into play in the use of hornlike protuberances in place of ordinary bosses and in the other nontraditional features of the bell. And all this was done by a painter. Here again is an example of an attempt to approach art from the sphere of nonart and to erase the boundary between the two.

CHAPTER NINE

Action Painting and Pop Art

So far in this book, all that has been said about action painting is that it differs from abstract painting and is a form of *art informel*. Here I would like to enlarge upon this point. The statement as it stands is not only incomplete but also somewhat in error, and an understanding of action painting must be supplemented from a different point of view.

The above definition of action painting is valid insofar as that form of painting is considered in contrast with abstraction. But the present age, not only in the art world but also in many other fields, is one in which disputes and conflicts occur between forces that are not necessarily extreme opposites of one another. On a large scale, this is evident in international politics, and on a smaller scale it can be seen in the disunity among student protest groups. An example a little closer to our topic is the problem of urban planning. In this sphere, the housing of the proletariat being ignored, the preservation of the pre-eminent rights of the wealthy and the mushrooming of large-scale construction and housing projects lock horns with each other in areas of air, sunlight, and natural scenery. The same situation has arisen among the various styles of art that we have gathered under the name of *informel*, stirring up further opposition beyond that existing between abstract art and *art informel*.

There is an obvious contrast between the stillness of *informel* painting and the movement implied in the very name of action painting. The theory behind action painting is that, whether the painter puts real or imaginary things on the canvas, the canvas itself, as Harold Rosenberg points out, is no longer a space for the reproduction, representation, analysis, or expression of anything other than the artist's act of painting. Instead, it is an arena for the action itself. While this theory may seem to be applicable also to *art informel,* actually it is not. It is quite clear that even the canvases of Mathieu, the most "actional" of *informel* painters, differ completely in their effect from those of an action painter like Jackson Pollock.

In the case of Mathieu, if we restrict our attention to the relationship between the artist and what is put on his canvas, we cannot positively say that something had been planned before the artist acted directly on the canvas. But the exactness of the horizontal lines and the arcs that cross over them and the charm of the groups of dots and little eddies seem to indicate the pre-existence of a plan that assumed dominance and control over the creative act of the artist, even though this plan may not have been an actual image of how the finished canvas should look. It is true that action is sometimes incited in Mathieu's work, but on the whole it is under the influence of something that limits action and seems to destroy spontaneity, thereby giving it an "aesthetic" character. That is why, at his one-man show in Tokyo some years back, Mathieu's works gave me the impression that they maintained their existence by virtue of

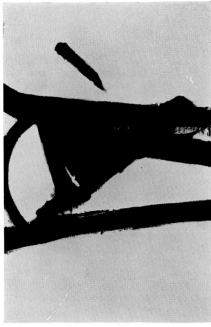

137. Franz Kline: Accent Grave. *Oils; height, 178 cm.; width, 128 cm. 1955.*

the fine quality of their paints. The dignity and composure of the paints and the overall effect of aristocratic serenity may not be the whole life of these works, but certainly they are the essential elements that hold them together. Mathieu's paintings derive their life not from any "actional" impression given by his method of production but from the effect of control.

Although the spotted-pattern paintings once produced by Sam Francis and Jean-Paul Riopelle show differences in distinctness of outline and thickness of paint, the figures that fill them speak clearly of artists who painted them one after another while moving about only within the necessary space before the stationary canvas. Needless to say, upon the completion of works like these, the canvas and the pattern put on it are no longer two distinct entities. Like a piece of cloth and the pattern dyed into it, they are a unity. In this respect, the canvases of these two artists differ from those of repre-

sentational painters, on which images of people, still life, and landscapes are superimposed, and from those of abstract painters, which are supposed to carry the pure products of the artists' ideation. (As if to enhance this impression, Sam Francis has left a few random drippings of paint on his canvases.) From the fact that their works are neither pictures in the traditional sense nor representations of things that already actually exist, it is clear that they were in agreement with the monistic intention of Fautrier in his establishment of *art autre*. Nevertheless, in producing these paintings, they limited their movements to those that were absolutely necessary, and therefore the paintings themselves, unlike the products of action painting, are not records of the artists' action.

In action painting, on the other hand, there is absolutely no regularized direction to the brush strokes, and the colors, exactly in the manner of a graph that records the changes taking place

138. Jasper Johns: Gray Numbers. *Encaustic, wood; height, 71 cm.; width, 56 cm. 1958.*

within a given length of time, seem to aspire to no other significance than that of a record of the movements the artist has made. Although, in the finished painting, the colors are now fixed and motionless on the canvas, we can nevertheless feel the dynamism of motion, and in this we must recognize the raison d'être of action painting. It is for this reason that the action paintings of Franz Kline (Fig. 137) and the consciously structured canvases of Pierre Soulages are entirely different in spite of the momentary similarity of pattern that they present at first glance.

ACTION PAINTING AND JAPANESE TRADITIONS For the same reason, we sense a complete difference between the works of Kazuo Shiraga (Fig. 90) and

those, quite naturally, of Yoshishige Saito (Figs. 52, 63) and even those of Toshimitsu Imai (Figs. 12, 30). The brush tracks in Shiraga's work are all only unmoving clots of paint, but the dynamism of the movement that left the tracks still persists. On his huge canvases, floods of red and black, red and yellow, or yellow and black paint are spread with a rather wide piece of board in one frenetic movement and then allowed to dry just as they are—all this in a manner in which there seems to be no regard for beauty at all. But the beauty is found precisely in the honest method of carrying the work through to completion without being distracted once it has begun. We can see here a reflection of the great Momoyama-period painter Kano Eitoku, who used bundles of straw instead of regular brushes to create huge murals and screens for the feudal lords of his time. But because Shiraga has been relieved of the burden of painting figuratively, there is much more freedom here than in the work of Eitoku. Nevertheless, not a few values were lost in the attainment of this freedom—a fact that perhaps foretells the fate of nonfigurative painting.

Then why has there not been more of such "actional" painting among the shortsighted and active Japanese, who are unsuited for the meticulous work of carefully analyzing and restructuring minute elements to create a realm of some sort? Is the echo of the Momoyama period that we have noted above merely a mutation and not a phenomenon that would have appeared in the natural course of events as an element of the Japanese national character?

The unabashed roughness of the throngs of prostitutes who swaggered through the streets immediately after the war—women who showed none of the melancholy or the weakness of the oppressed —often reminded me of the famous early-Edo-period genre painting *Yuna* (Bathhouse Girls), and I must admit that the same sort of impression has entered into the way in which I judge Shiraga's paintings. Moreover, as I have noted before, there are several good reasons why Japan's postwar period may be called a new Momoyama period.

The reason why contemporary Japan allows only a limited development of culture in Momoyama

fashion seems to lie in the difference between the two historical situations. The Momoyama period was a rare interval in cultural history that began when a free and undefeated Japanese people met on an equal footing—subjectively, at least—with the more advanced and flourishing culture of the Renaissance through the agency of the Jesuits who had come to recover in the Orient the prestige that had been lost in Europe. In 1945, however, Japan was a defeated nation, and the Western culture that rushed in had incomparably better-organized directive power than that which entered the country in the latter part of the sixteenth century, so that there was absolutely no room for selection by the Japanese. Without doubt there are tendencies toward some elements of Momoyama style in postwar Japanese literature, art, and life styles, but they seem to me to be irritatingly undeveloped or to be localized only in narrow fields. This, of course, is a contemporary view, and how a cultural historian four centuries from now will view the current age is an open question.

It would certainly be ridiculous if I were expressing irritation over the lack of Momoyama style in areas that have nothing at all to do with that style. But that is not what I am doing here. The present situation in our cultural history is such that there are basic factors from which Momoyama-style trends can spring, but the same factors are keeping them from assuming greater prominence. Another point to be borne in mind in considering the differences between the international political conditions surrounding Japan in the late sixteenth century and in the mid-twentieth century is that, unlike their Momoyama-period counterparts, Japanese artists since the 1920s have had the burden of producing their work as individuals left abandoned outside the political system.

The warring lords who caused the downfall of the Muromachi shogunate (1336–1568), which bequeathed to the new age so much of antique character, themselves had some residue of the ancient rulers' mentality. Although the new line of warlords after Oda Nobunaga (1534–82) also showed some yearning for the old, as, for example, in desiring to be enshrined as deities, in politics they rid

139. *Nobuaki Kojima:* Shimbashi (2). *Oils; height, 162 cm.; width, 130 cm. 1966.*

themselves totally of the past through their respect for power and pragmatism instead of convention, authority, or rites. The new spirit of leaders like these harmonized with the newness of the art of the times, as exemplified in Kano Eitoku's ink paintings at the Kyoto temple Juko-in, and permitted the formation of a common realm of warriors and artists, thereby making possible the production of massive wall and screen paintings that still survive today. Such cooperation with the men in power is clearly something that today's artists do not enjoy, as is proved by the basic dissimilarity between what today's political leaders are trying to obtain from foreign countries and what artists are trying to absorb from those same countries. It goes without saying that the politicians of the present age have none of the interest

140. *Jiro Takamatsu:* Identification. *Wall paints. 1966.*

in Western culture that Oda Nobunaga and Toyo-
tomi Hideyoshi showed during the sixteenth cen-
tury. Each artist picks up for himself a foreign style
of art that suits him, even if it seems at first glance
that everyone is following the same style. If each
artist is confined in a purgatory of solitude, there
is no way that another Kazuo Shiraga can appear
on the scene to give new life to the old Kazuo
Shiraga.

FORMALISM WITH-
OUT MEANING

We note here that Jean-
Paul Riopelle and Sam
Francis, who once pro-
duced canvases in dappled patterns, never returned
to this style after they had advanced into new ones,
Riopelle with his rough, fretful action painting
and Francis with his lapis-lazuli spheres that seem
to be dancing out from within white paper. By
way of contrast, it is difficult to name a Japanese
informel artist who has pierced through his own
impasse, although a few have made some super-

ficial alterations in style. After Kazuo Shiraga
there came a sort of meaningless formalism. One
example of this is op art, but there is another as
well. One may call the latter *informel* in the sense
that it does not have any definite message to be
conveyed by form. But it ignores the demand for
dialogue between viewer and painting to a greater
extent than *informel* does and concentrates on the
production of form that gives the impression of
having been completed by mere chance in some
world utterly detached from that of the viewer.
There is a constructive element in it that is absent
in *informel* painting. Nevertheless, the essence of it
does not seem to be its compositional character
but its realization of futility.

For example, it was at first an astonishment to
come upon Kumi Sugai's *Blue* (Fig. 31) at the 1962
Salon de Mai Japan Exhibition. Suddenly I was
confronted by a huge and altogether indescribable
blue figure wearing a red hat. But the painting
said nothing at all to me as I stood there gazing

at it. It fulfilled none of my expectations and seemed to be merely trying to make me laugh at the fact that it had left me standing there grasping at nothing. And that was all there was to it.

The same thing would hold true for the artist who gains a reputation for himself by dripping paint on the canvas. The tracks of the paint may not always produce an interesting pattern, but then, quite accidentally, they may. So if you drip enough paint on the canvas, the added variety will increase the probability of achieving an interesting pattern rather than an uninteresting one. Here the artist merely ascertains the effect. Another method of drawing attention is to throw paint at the canvas to create a splash effect. The dripping and throwing actions are themselves aimless (we might venture to say that a robot could do the same) and therefore are not the actions of an artist. Here again the artist's job consists only of getting the paints together and making sure of the effect.

This is what I mean when I speak of "meaningless formalism." What takes precedence here is not the model form, as in the old formalism, although it cannot be denied that a concept of form exists. If there were no concept of form here, there would be no room for the establishment of an art fad that enjoys the casual dripping or throwing of paint. For the same reason, formalism was always apparent in surrealism, which aimed at the spontaneous embodiment of the subconscious. It is only by means of the sense of form that one can pass judgment on something that has come about accidentally as to whether it is worth retaining or not, without even considering the meaning of it. Therefore the rule of form takes precedence.

THE INDESCRIBABILITY OF CONTEMPORARY PAINTING

Even the greatest and most sympathetic Japanese advocates of avant-garde art—like Shuzo Takiguchi, for example—admit that contemporary painting, including what has to go out of its way to call itself contemporary, is no longer describable with words. One can label it with such names as *art informel,* action painting, op art, pop art, and so on, but it is impossible to describe verbally what is actually depicted on any canvas. It can be identified as to style and technique, but just as the concrete picture of a type of airplane cannot be accurately grasped or even imagined from its name alone, so the names given to particular styles or techniques of painting require one to be acquainted with the pictures first if these names are to have any significance for him. It is as though, when we see a picture, our exclamation of appreciation itself becomes the designation of the technique or the style.

It has been true in any age that the source from which the essential attractiveness of a painting springs cannot be explained by words, and it is also true that the names of all the styles and techniques were originally no more than labels. In fact, the relation of a word to the notion it expresses is basically arbitrary. The only case in which a word is understood when heard is the case in which the association, established in the past beyond recollection, has reached us as what may be called a universal subconscious memory. Even so, one cannot always avoid error. For example, unless one is especially familiar with the subject, one is not likely to hear the word "pasture" and immediately think of a pasture in winter with its dried grass, as a person acquainted with such a scene would do, or to hear the words "cherry blossoms" and to be reminded of cherry blossoms as a symbol of the transience of worldly things, as in the eighth-century Japanese poetry anthology *Man'yoshu.* From the time of cubism on, artists have come to express on canvas things that are more and more difficult to express in words. This trend no doubt reflects the progress of the movement to rid painting of the literary quality that characterized it in the nineteenth century. On the other hand, we can also say that painting has returned for the first time to its origins as a form of expression.

Just as a score is indispensable to the recording of music, so photographs are indispensable to a discussion of contemporary painting. There was a time when the birth of photography caused some ambitious painters to attempt to rival it in technique. In the end, however, the function of recording was left to photography, and it is ironic indeed that

now, after several generations of painters who believed that they should do what photography could not do, we should find photography necessary to painting. This means not only that a correspondence between the two has been recognized but also that we see here an inevitable development arising out of their intrinsic and necessary relationship. That is to say, there is a good possibility that the materialization of styles of painting that defy verbal description relied on a means, such as photography, of fair and accurate (unless purposely distorted) reporting. In a word, artists produce their indescribable canvases secure in the knowledge that many will see their work. Again, if the transportation of paintings and the mobilization of viewers had not been made easier, faster, and greater in scale—in short, if art exhibitions had not expanded throughout the world—artists, I imagine, would have earnestly spent more time in an effort to produce works that would gain the greatest possible understanding of their own countrymen and would, at the same time, be much easier to discuss, both at home and abroad. Do we not see here one of the reasons for the link between the nonfigurative character and the internationalism of contemporary painting?

But now we come to Jasper Johns. As a painter, he produces a picture filled with the American flag and with only a little white margin left at the bottom, then a canvas in which there is only a yellowish-gray figure 5, and then another "picture" in the middle of which he glues a canvas stretcher and paints the rest of the area in the same yellowish gray. He makes exact replicas of such things as light bulbs, shoes, and toothbrushes in aluminum. Again, in heavy metal, he makes an equally exact replica of a beer can and of a container with paintbrushes standing in it and colors them exactly like the original models. The simulated paintbrushes, untidy and clotted with paint, gleam here and there like real brushes.

What are we to make of all this? Certainly in a work like the one featuring the beer can and the paintbrush container we do not have a dualism of work and model. The work is not conceived of as a substitute for the model or as subordinate to it,

even though it copies the mod[el] of this a real beer can and a r[e]tainer were conspicuously pla[ced] work when it was exhibited. Th[is] not to demonstrate its verisimi[litude] to proclaim its will to exist in[dependently of its] model and, by closely resembl[ing it,] usurp the model's raison d'êtr[e by ap]pealing to the viewer's eye. At th[is proc]lamation is what must be called [nihilism.]

There appears to be a traditi[on of real]ism in America, even to the poi[nt that it] is a realism that came into existe[nce related] to the feelings of the artist towa[rd it and] sometimes gives rise to works tha[t have a weird] or mysterious effect. It is safe to sa[y that the] existence of this tradition makes po[ssible the ap]pearance of talents like that of Jasper Johns.

While realism is expressed in two dimensions in ordinary painting and in three dimensions in sculpture, the realism of Johns may be said to be four-dimensional. What is apparent in his work is the desire and the will to copy the principle by which something is the thing it is, or even the process by which it has become what it is. If Johns succeeds in this attempt at four-dimensional realism, his achievement is tantamount to usurping the place of reality and denying it altogether.

JAPANESE POP ART We now understand how the nihilism of Jasper Johns is constituted. Then what about Jiro Takamatsu, who portrays not objects but their shadows, and very realistically at that (Fig. 140)? The work of his in which a woman's red high-heeled shoe is fixed to the canvas and serves as a base point for painting the leg and shadow of a woman standing on a sidewalk looks like a combination of painting and photography done for a poster and is not really very interesting. But there is one work of his that did surprise me. Here there were stacks of shelves, each divided into many sections, and painted in each of these divisions were the shadows not only of the shelves and the section dividers themselves but also of whiskey bottles, whiskey glasses, flowers in vases, a woman's purse, what appeared to be gloves, and

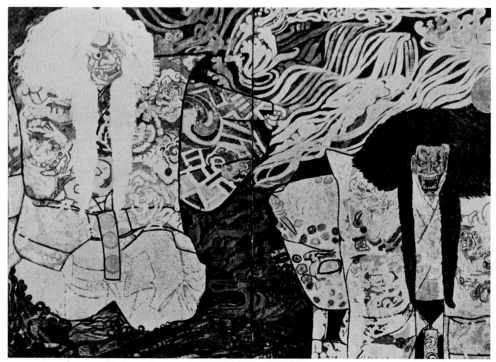

141. *Tamako Kataoka:* Admiration. *Colors on paper; height, 230 cm.; width, 360 cm. 1960.*

many other small articles of daily use, each shadow painstakingly done in true-to-life colors and shades.

To be sure, these shadows were skillfully and truthfully rendered, but that is not why I was impressed. What did impress me, just as it has done in the work of Johns, was what did not exist in the painting. But there is a great difference. What I admire in Johns's case is his thorough attitude, in facing reality, of treating what is absent as nonexistent, whereas my surprise at Takamatsu's work had a much simpler cause. In his case, we cannot help feeling that his shadows lead us into suspecting or assuming the existence of the real things whose shadows they are. That is, although by presenting us with only negative images he seems to succeed in causing our minds to form positive images, what he shows us is not the reality of the negative world. What we see here is the peculiarly

Japanese lack of an attitude of going into a matter thoroughly and then, upon mastering it, detaching oneself from it—the attitude of pursuing the realistic method to its consummation and then separating oneself from it.

Ushio Shinohara's enlarged parodies of color woodblock prints certainly concern themselves with a long-neglected theme. Still, while he seems to be engaged in an undertaking worth pursuing, the results are somewhat dissatisfying, for he does not go far enough in the rejuvenation of the woodblock print, which might have been possible through an enlarged but out-and-out imitation, or in giving us a thoroughgoing caricature of the present age. The reason seems to be that he lives in perfect harmony with the environment out of which his works are born. The feeling of liberation present in these works is not strong enough to invite hearty laughter, and there is an uneasiness about them

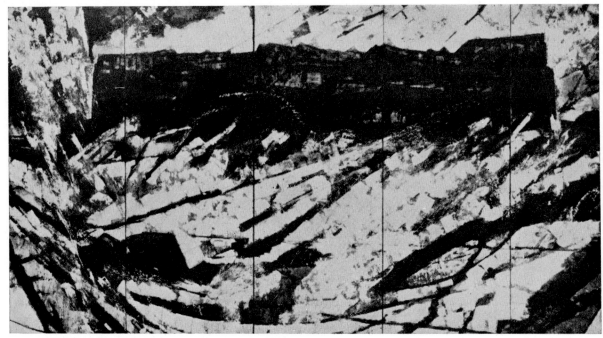

142. Misao Yokoyama: Surging Waves. *Oils and watercolor on paper. 1960.*

that seems to be filled with the danger of degeneration.

Certainly there is in the works of such artists an irony directed at themselves and at art as well, but we know from experience that weak irony offers nothing more than a degree of enticement. I only hope that pop art (or should I say imitation art?) will not take on the perverse self-justification that I so intensely dislike in certain Edo-period artists. Still, there is a definite feeling that recent artists are attempting to find new directions through figurative art. For example, let us look at Keiji Usami's *Old-fashioned Arcade* (Fig. 85), a huge canvas that resembles a billboard after a cloudburst, its colors all running. Here the flattened and fragmentary shapes of the white nudes can be viewed as the expression of an inner image (whether it be a latent memory or not) that we do not necessarily make explicit but, at the same time, recognize as being too valuable to be eliminated. We can also see here the idea of self-rescue or self-sustainment through the aid of the figurative.

A FEW FINAL OBSERVATIONS With what I have said up to now, I think I have fairly well exhausted what I can say about the subject that was assigned to me. What is left to do is to express my feelings about certain individual works of Japanese art, but this cannot be done satisfactorily without going beyond the restrictions imposed by the word "contemporary" as I have tried to define it earlier in this book.

Let me speak first here of a work from the Kamakura period (1185–1336): the gilt-bronze Stupa of the Five Elements, which is now preserved at the Konomiya Shrine in Shiga Prefecture. Its donor was the Jodo-sect priest Chogen (1137–1206), who was in charge of the twelfth-century reconstruction of the Todai-ji, the famous temple in Nara, and whose name, together with the power and dignity

of the stupa itself, makes us associate it with the architectural style that Chogen brought over from Sung-dynasty (1127–1279) China. This is the so-called Indian style, which was used in the construction of the Todai-ji gate known as the Sammon. Here, through the consistency that we observe in the artistic judgment of one man, we are made aware of the universality and the apprehensive or awakening power of art—a power that increasingly diminished in Japanese art after the Kamakura period and, in the present context, calls for my reflections upon it as an element that must be once again realized in contemporary Japanese art.

The capacity for the striking portrayal of individuals and crowds that we see in the picture scrolls of the late Heian (794–1185) and Kamakura periods is by no means a glory forever lost, and it forcibly suggests to us a dynamism that could very well be revived even in the nonfigurative painting of today, which tends to give the impression that it has no interest in moving on from its present static position. Another potential subject for study by contemporary artists is the Buddhist paintings of the early Heian period. The profound and rich sensitivity that enabled them to penetrate the depths of the human spirit is a quality that modern painting has lost and has the task of recovering.

Much more recently, we have the works of Tetsugoro Yorozu. In addition to his well-known fauvist and cubist works, he produced a small untitled abstract painting in which geometrical figures in beautiful tones of color combine to create a lyric feeling—a painting thought to date from the year 1912—and a small expressionistic fantasy called Gas Lamp. If, at the outset, I had not limited my definition of the contemporary period, these works would have been a natural subject to include among those previously discussed in this book.

There is also the matter of contemporary nihonga, or Japanese painting in traditional style as contrasted with Western-style painting. We have for example, an artist like Taku Iwasaki, whose habitual use of the mineral pigments of nihonga led him quite easily to the idea of affixing rusty iron plates to painted surfaces that resemble hardened sand.

There are also artists like Tamako Kataoka, who has made the most of the special character of nihonga that permits it to assume as much decorative quality as one desires and who succeeds in creating a sumptuous, resplendent effect that I find quite rare in recent painting (Fig. 141). In both of these instances the freedom acquired by a mind nurtured in the use of mineral pigments, which are of low viscosity and therefore have little of the magical power to capture the viewer and bind him to a painting, led the artist to a concept of space different from that held by traditional artists, who were totally engrossed in the canvas. We can describe artists like Iwasaki and Kataoka on the one hand as using novel subjects in a sure and infallible way and, on the other, as fearlessly creating a decorative style that derives not from the logic dictated by the canvas itself but from the freedom with which the artist employs his own taste.

The success of Misao Yokoyama's huge painting of a mountain done in silver and the glossy black of India ink lies in his wise use of his subject matter and in the freedom given him by a style that does not make a necessity of realism. The work of artists somewhat senior to Yokoyama, who achieved their fame through the fantasy and abstraction of their styles but could not quite escape the traditional in their techniques of production, gives the impression that the existence of the artist is confined within the painting. Yokoyama's painting, on the other hand, displays a truly contemporary spirit. It has the power to thrust itself upon the viewer regardless of what the particular style he favors may be.

If I am to name the single feature that is common to the nihonga of contemporary artists, I can say, with no intention of insisting obstinately upon a point that I have made before, that it is the Momoyama character. There is a clear trend among present-day painters: the trend toward freedom from their métier—that is, both from their being painters as such and from the restrictions on the variety of techniques to be used in their profession. This trend may not yet be displayed in the majority of contemporary nihonga works, but it becomes apparent when we take a close comparative look at the paintings of former times.

Major Events in Postwar Japanese Art

1945. Termination of World War II sees abolition of promilitary groups, such as Greater Japan Art National Society, that had controlled artists' activities; Nika-kai (Second Division Society) re-established; Action for Art Association founded.

Japan surrenders unconditionally; liberalist philosopher Kiyoshi Miki dies in prison; New Japanese Literature Society (Shin Nihon Bungaku Kai) founded; literary journals *Shincho* (New Tides) and *Bungei Shunju* (Literary Art Spring and Autumn) revived.

1946. Bunten (Ministry of Education Art Exhibition) changes name to Nitten (Japan Art Exhibition) and sponsors two exhibitions, Ministry of Education simultaneously establishing a culture and an art section to run Nitten; art world shaken over question of whether to participate in Nitten reform plan; Women Painters Association (Joryu Gaka Kyokai) founded.

New Japanese constitution proclaimed; May Day observances resumed; art periodicals *Atelier* and *Mizue* (Watercolor) revived and *Sansai* (Tricolor) started; *Chuo Koron* (Central Public Opinion) and *Kaizo* (Remodeling) magazines revived and *Sekai* (World), *Ningen* (Man), and *Tembo* (Outlook) started.

1947. Mainichi Shimbun sponsors first Joint Exhibition of Artists' Groups; Japan Art Society sponsors first Japan Independents exhibition, to be held annually; Modern Japanese Western-style Painting exhibition held at Tokyo National Museum; Shinju-kai (New Tree Society), Dai-niki-kai (Second Era Society), Jigen-kai (Divine Revelation Society), Japan Avant-garde Art Club, Japan Sculptors League, and Art and Handicraft Society founded;

Kunio Maekawa designs new Kinokuniya Building; Junzo Yoshimura holds silk fair.

Yomiuri Shimbun sponsors Famous Western Paintings exhibition; Imperial Household Museum becomes Tokyo National Museum; Imperial Art Academy changes name to Japan Art Academy; Japan PEN Club re-established; theatrical troupes Budo no Kai (Grape Society) and Mingei-za (Popular Art Theater) formed.

1948. Avant-garde tendencies toward surrealism and abstraction more noticeable at every public art exhibition; beginning with fourth exhibition Nitten is sponsored by Japan Art Academy, and seven artists' groups announce their rejection of Nitten; a group called Creative Art (Sozo Bijutsu) formed and becomes the base for a new movement in traditional Japanese-style painting; Itto-sho (One-Lamp Award) established, the judges being Sotaro Yasui (1888–1955) and Ryuzaburo Umehara (1888–), and the winner Yutaro Okuda; Takanori Ogisu (1901–) visits France, the first such postwar trip.

International Military Tribunal for the Far East ends; second Famous Western Paintings exhibition held; Japan Art Academy Award resumed; *Bijutsu Techo* (Fine Arts Handbook) and *Bi no Kuni* (Land of Beauty) magazines revived; International Abstract Art Exposition held in Paris.

1949. Yomiuri Shimbun begins sponsoring Japan Independents exhibitions; architectural division added to New Productionist Association (Shin Seisaku-ha Kyokai); exhibition of paintings by Ryuzaburo Umehara and Sotaro Yasui held; Mainichi Art Award inaugu-

rated, the winners being Takeshi Hayashi, Heihachiro Fukuda, and Kazuo Kikuchi; Art Critics Union, Japan Artists League, and Rikki-kai founded; joint sponsorship of Nitten by Japan Art Academy and Nitten Administration Committee begins; Tsuguharu Fujita visits U.S.A.; Handicraft Guidance Office begins advising on industrial design; Kenzo Tange wins first prize in Hiroshima Peace Memorial Park and Hall competition; Yoshio Taniguchi designs Toson Shimazaki (1872–1943) Memorial Hall and Keio University Student Hall.

Horyu-ji Golden Hall, Nara Prefecture, burns down; members of theatrical troupe Zenshin-za (Advance Theater) join Japan Communist Party; Hideki Yukawa awarded Nobel Prize for physics for his meson theory; Sanjugo Naoki and Ryunosuke Akutagawa literary awards revived; Picasso produces *Dove of Peace;* periodical *Art d'Aujourd'hui* started; Auguste Herbin publishes *Nonfigurative Nonobjective Art.*

1950. Asahi Shimbun sponsors Excellent Art exhibition, to be held annually; Mainichi Shimbun starts Shoen Uemura (1875–1949) Award; Atelier Company starts Atelier New Face Award, the winner being Hiroshi Ono; Modern Art Association founded; sculptural division added to Action for Art Association; plastic-arts division (members including Takashi Kawano, Hiroshi Hara, and Yusaku Kamekura) added to Dainiki-kai; Isamu Noguchi visits Japan to hold one-man show; Sutemi Horiguchi designs Goko-no-ma room in Hasshokan Hall.

French art films *Rodin, Maillol, Van Gogh,* and *Matisse* introduced to Japan; periodical *Geijutsu Shincho* (New Tides in Art) started; University of Tokyo authorities reject installation of Shin Hongo's *Hear the Sea God's Voice* to maintain political neutrality; Kinkaku-ji Golden Pavilion, Kyoto, destroyed by arson.

1951. Works of fourteen Japanese-style painters including Shinsui Ito, seventeen oil painters including Saburo Miyamoto, seven sculptors including Kazuo Kikuchi, and eight print artists including Koshiro Onchi exhibited at São Paulo Biennale First International Art Exhibition; Junzo Itakura and Takeshi Takemoto participate in São Paulo International Architectural Exhibition; Kanagawa Prefectural Museum of Modern Art, Kamakura (designed by Junzo Itakura), opens as Japan's first museum of modern art; Mainichi Shimbun sponsors Exhibition of Contemporary French Art: Salon de Mai Japan Exhibition; New Productionist Association and Creative Art unite as New Production Association; cartoon and commercial-art divisions added to Nika-kai; Japan Advertising Art Society founded; sculpture goes into the streets as Kazuo Kikuchi erects *Group Sculpture for Peace* at Miyakezaka, Tokyo, and Takashi Shimizu installs *Green Rhythm* in Ueno Park, Tokyo; Antonin

Raymond designs Reader's Digest of Japan building, Tokyo; Yoshio Taniguchi and Isamu Noguchi design Banraisha hall.

Henri Matisse and Pablo Picasso exhibitions held in Tokyo; exhibition of works by Tawaraya Sotatsu and Hon'ami Koetsu (1558–1637) held at Tokyo National Museum; Japanese Traditional Art exhibition (including 177 national treasures and other valuable works) tours U.S.A.; periodical *Museum* started; Japan joins UNESCO; Japanese film *Rashomon* awarded *grand prix* at Venice Film Festival; Kabuki-za theater in Tokyo reopens; Michel Tapié organizes an exhibition of nonfigurative painting.

1952. Mainichi Shimbun sponsors first Japan International Art Exhibition exhibiting 450 works from France, U.S.A., U.K., Italy, Belgium, Brazil, and Japan; National Museum of Modern Art and Bridgestone Art Museum open at Kyobashi, Tokyo; eleven artists including Ryuzaburo Umehara and Taikan Yokoyama exhibit works at Venice Biennale; seventeen artists including Hanjiro Sakamoto exhibit works at Carnegie International Art Exhibition, Pittsburgh; eighteen artists including Takeshi Hayashi and Okahito Yamamoto participate in Twentieth-Century Masterpieces exhibition, Paris; Soichi Tominaga participates in fourth World Art Critics Conference, Switzerland, and Yoshinobu Masuda in first International Artists Conference, Venice; Shiko Munakata and Tetsuro Komai awarded prizes at Lugano International Block Print Exhibition; Mainichi Shimbun sponsors first New Japan Industrial Design Exhibition; Japan Industrial Designers Association (JIDA) founded; Kunio Maekawa designs Japan Sogo Bank building.

Mischa Black exhibition held in Tokyo; Cultural Assets Research Institutes opened in Tokyo and Nara; Kyoto Museum becomes Kyoto National Museum; periodical *Bijutsu Hyoron* (Art Commentary) started; Japan Communist Party central organ *Akahata* (Red Flag) resumes publication; Le Corbusier completes Unité d'Habitation in Marseilles; Michel Tapié organizes "What *Informel* Means" exhibition and begins publication of *Art Autre;* Harold Rosenberg creates the label "action painters" for a group of American artists.

1953. Abstractionism and Fantasy exhibition held at National Museum of Modern Art; seventeen artists including Taro Okamoto exhibit works at São Paulo Biennale; twenty artists including Kaoru Yamamoto and Insho Domoto exhibit works at second International Contemporary Art Exhibition, New Delhi (sponsored by the Indian government); seven artists including Toshio Kasagi exhibit works at "Unnamed Political Prisoners" International Sculpture Contest at Tate Gallery, London; Japan Abstract Art Club, International Block

Print Association, and Japan Copperplate Print Association founded; photography division added to Nika-kai; Isato and Toshiko Maruki, painters of *Depiction of the A-Bomb,* receive International Peace and Culture Award; nudes entitled *Michinoku* (Deep North) by Kotaro Takamura (1883–1956) installed at Lake Towada, Aomori Prefecture; Jiro Kosugi's *Head of Janome Sewing Machine,* which received first prize in second New Japan Industrial Design Contest (sponsored by Mainichi Shimbun), exported; Hiroshi Oe designs Hosei University Graduate School; Mamoru Yamada designs Tokyo Health, Welfare, and Pension Hospital; Kenzo Tange designs Tange residence.

Georges Rouault and Lucien Coutaud exhibitions held in Tokyo; Japanese Traditional Art exhibition (77 paintings and 14 sculptures) tours U.S.A.; Japan-France Cultural Agreement signed; Japan Broadcasting Corporation (NHK) and Nippon Television Network Corporation (NTV) begin full-scale telecasting; American Contemporary Painting exhibition held at Musée National d'Art Moderne, Paris.

1954. Mainichi Shimbun sponsors Japan Contemporary Art Exhibition, to alternate annually with the Japan International Art Exhibition; Hanjiro Sakamoto and Taro Okamoto exhibit works at Venice Biennale; Japan-U.S. Abstract Art Exhibition held in New York; Taro Okamoto and Kakuzo Tatebatake invited to exhibit works at Salon de Mai, Paris; Posthumous Works of Yasuo Kuniyoshi exhibition held at National Museum of Modern Art; Hanjiro Sakamoto receives Mainichi Art Award; Yuki Ogura receives Shoen Uemura Award; Tsuguharu Fujita becomes French citizen; Art Critics League founded (chairman, Teiichi Hijikata); *shoin*-style house designed by Junzo Yoshimura completed in courtyard of Museum of Modern Art, New York; Kunio Maekawa designs Kanagawa Prefectural Library and Concert Hall; Kenzo Tange designs Haramachi factory of Tosho Printing Co.

Walter Gropius visits Japan; "Gropius and the Bauhaus" exhibition held at National Museum of Modern Art; French (Louvre) Art, Etchings of Goya, and Ossip Zadkine exhibitions held in Tokyo; Roka Hasegawa completes mural *Twenty-six Japanese Martyrs* at a Franciscan monastery in Italy; Horyu-ji Golden Hall repairs completed.

1955. Japan-U.S. Abstract Art Exhibition held at National Museum of Modern Art; "Today's New Star 1955" exhibition held at Kanagawa Prefectural Museum of Modern Art; Kazu Wakita and Kinosuke Ebihara win Domestic Award at Japan International Art Exhibition; Shiko Munakata receives prize in block-print division of São Paulo Biennale; Waseda University Architecture Department awarded first prize at São Paulo

International Architectural Exhibition; Le Corbusier visits Japan to design National Museum of Western Art; Industrial Design Award added to Mainichi awards; Ichiyo-kai founded; Aichi Prefectural Art Museum opens; Kenzo Tange designs Hiroshima Peace Memorial Hall; Kunio Maekawa, Junzo Itakura, and Junzo Yoshimura design International House; Yoshio Taniguchi designs Shiga residence.

Three-man show by Le Corbusier, Fernand Leger, and Charlotte Perriand and Mexican Art and Contemporary Italian Art exhibitions held in Tokyo; first world rally to ban nuclear bombs held in Hiroshima; Mainichi Publishing Cultural Award goes to *Muro-ji Temple* (publisher, Bijutsu Shuppansha; photographer, Ken Domon); Le Corbusier completes Ronchamp chapel of Notre-Dame-du-Haut.

1956. *Art informel* introduced at Exposition Internationale de l'Art Actuel (sponsored by Yomiuri Shimbun); Kazu Wakita receives Japan Domestic Award from Guggenheim Foundation; Tomoaki Hamada wins prize at Lugano Fourth International Block Print Exhibition; Shiko Munakata wins prize in block-print division at Venice Biennale (Japan House, used for the exhibition, was designed by Takamasa Yoshisaka); twenty-six artists including Kinosuke Ebihara participate in International Watercolor Biennale held at Brooklyn Museum; Shell Oil Co. starts Shell Art Award, the winner being Akira Tanaka; Sotaro Yasui Award established, the winner being Kon Tanaka; Junzo Yoshimura wins Persons' Award; Ishibashi Art Museum, Kurume, Fukuoka Prefecture, opened; Yoshio Taniguchi designs Chichibu Second Cement Factory; Kenzo Tange designs Kurayoshi City Office, Tottori Prefecture; Takamasa Yoshisaka designs Ura residence.

"Sculpture and Paintings by Emile Antoine Bourdelle" exhibition held in Tokyo; Japan joins the United Nations; Enryaku-ji Lecture Hall and Bellhouse, Shiga Prefecture, burn down.

1957. Tokyo International Block Print Biennale held at National Museum of Modern Art; Georges Mathieu and Sam Francis hold one-man shows in Japan, and *art informel* becomes focus of attention; Tsunesaku Maeda wins *grand prix* at first Asian Young Artists Exhibition; at São Paulo Biennale, Yozo Hamada wins highest award in block-print division, and Waseda University Architectural Design Department highest award in architecture division; at Milan Triennale International Handicrafts Exhibition, Kanjiro Kawai (1890–1966) wins *grand prix,* and Hyosaku Suzuki and Harusuke Kawakami gold awards; Kotaro Takamura Award started, the winner in sculpture division being Yoshitatsu Yanahara; Japan International Design Association founded; Kenzo Tange designs Tokyo Metropolitan Government Office;

Togo Murano designs Sogo-Yomiuri Hall; Sutemi Horiguchi designs Iwanami residence.

Twentieth-Century Design exhibition held at National Museum of Modern Art; Mainichi Publishing Cultural Award goes to *Shugaku-in Rikyu* (Shugaku-in Detached Palace; publisher, Mainichi Shimbun; photographer, Shinzo Sato); Twenty-ninth International PEN Conference held in Tokyo; Japan-Germany Cultural Agreement signed; Michel Seuphor's *Dictionary of Abstract Painting* published; Jean Fautrier holds large one-man show in New York.

1958. Michel Tapié, advocate of *art informel*, visits Japan to organize New Painting World Exhibition (*Informel* and Figurative); Gen Yamaguchi and Yozo Hamaguchi win prizes at fifth Lugano International Block Print Exhibition; Kenzo Okada wins prize at Venice Biennale; Minoru Kawabata and Kaoru Yamaguchi win prizes at Guggenheim International Art Exhibition; Akira Hasegawa wins prize at Pittsburgh International Painting and Sculpture Exhibition; Kenzo Tange is first winner of Pan-Pacific Award, established by American Architects Association; Japan builds pavilion (designed by Kunio Maekawa) and garden at Belgian World Exposition, Brussels; Japanese Contemporary Art exhibition tours Europe, Australia, and New Zealand; Kenji Imai designs Morie Ogiwara's Rokuzan Art Museum; Kenzo Tange designs Kagawa Prefectural Office and Sogetsu Hall; Kunio Maekawa designs high-rise housing development at Harumi, Tokyo; Seiichi Shirai designs Zensho-ji temple, Chiba Prefecture; Isoya Yoshida designs Umehara residence.

Vincent Van Gogh exhibition and Posthumous Works of Georges Rouault exhibition held in Tokyo; Kazuo Kikuchi's *A-Bomb Child* erected at Hiroshima Peace Memorial Park; Emilio Greco's *Bathing Woman* erected in front of Shirokiya Department Store, Tokyo; Hideo Kobayashi receives Noma Award for his essay "Modern Painting"; Boris Pasternak rejects Nobel Prize for literature; "Origin of *Art Informel*" exhibition held in New York; Jasper Johns holds his first one-man show in New York.

1959. Le Corbusier designs National Museum of Modern Art in Tokyo, first director being Soichi Tominaga; Minoru Kawabata wins prize at São Paulo Biennale; Yoshio Domoto, Minoru Kawabata, and Yasukazu Tabuchi receive prizes at Premio Risone Art Exhibition, Italy; Yoshishige Saito receives Paris International Art Critics Association Award; Kinosuke Ebihara receives Mainichi Art Award in fine-arts division; Kazuo Yagi receives gold prize and Shoji Hamada silver prize at second International Ceramics Exhibition, Ostend; Kenzo Tange receives International Award from French architectural periodical *Architecture Aujourd'hui; Mizue*

Award started, winners being Tatsuya Nakamoto, Seiichi Yuno, and Misao Yokoyama; six artists including Tatsuoki Nambata, having withdrawn from Free Art Association, form Japan Abstract Artists Association; Craft Center inaugurated at Maruzen, Nihonbashi, Tokyo; Ishikawa Prefectural Art Museum, Kanazawa, Ishikawa Prefecture, opens; Yoshio Taniguchi designs Chidorigafuchi Unknown Soldiers Cemetery, Tokyo; Kunio Maekawa designs Setagaya Ward Citizens Hall; Kiyonori Kikutake designs Kikutake residence.

Periodical *Design* started; Jean Tinguely begins production of "mobile scrap sculpture."

1960. "A New Generation of Traditional Japanese Painting" exhibition held at National Museum of Modern Art; Thirty-seven nations participate in second Tokyo International Block Print Biennale at National Museum of Modern Art; Tsuguharu Fujita Exhibition sponsored by Hirano Collection; Yoshishige Saito receives a Guggenheim Award, and Kenzo Okada a Ford Foundation Award; Jun'ichiro Sekino and Tomio Kinoshita receive Seattle Art Museum Award at thirty-first Northwest International Block Print Exhibition, held at Seattle Art Museum, Washington; Roka Hasegawa receives Kan Kikuchi Award for *Twenty-six Japanese Martyrs;* avant-garde sculptors' group Contemporary Sculpture founded; World Design Conference held in Tokyo; Yoshio Taniguchi designs Crown Prince's palace; Kunio Maekawa designs Kyoto International Conference Hall; Kenzo Tange designs Kurashiki City Office; Takenaka Komuten Co. builds Kansai Electric Power Company.

Twentieth-Century French Art exhibition, Albert Marquet exhibition, Exhibition of Famous Works Selected from the Former Matsukata Collection, Contemporary Australian Block Print Exhibition, and Ossip Zadkine exhibition held in Tokyo; new Japan-U.S. Security Treaty goes into effect; color telecasting begins in Japan.

1961. "Experiment in Contemporary Art" exhibition held at National Museum of Modern Art; Yozo Hamaguchi and Kumi Sugai win prizes at Ljubljana International Block Print Biennale, Yugoslavia; Yoshishige Saito becomes first Japanese artist to receive Foreign Award at São Paulo Biennale; at International Symposium of Sculpture in Yugoslavia, Eisaku Tanaka wins first prize in wood sculpture division, and Hajime Togashi second prize in stone sculpture division; Tamako Kataoka receives Recommended Art Award; Suntory Art Gallery opens in Palace Hotel, Tokyo (constructed by Takenaka Komuten Co.); Kunio Maekawa designs Tokyo Metropolitan Festival Hall; Isoya Yoshida designs Yamato Bunkakan, Nara.

French Art exhibition (mainly of works from the

Louvre), Le Corbusier exhibition, Paul Klee exhibition, Block Prints of Picasso exhibition, and Sculpture of Emilio Greco exhibition held in Tokyo; American architect Buckminster Fuller visits Japan.

1962. Kumi Sugai wins prize at Venice Biennale; Hideo Ogiwara and Hodaka Yoshida win prizes at Lugano International Block Print Exhibition; Kanjiro Kawai wins prize at Prague International Ceramics Exhibition; Yoshinosuke Shimomura and Seiji Shimizu win prizes in fine arts division of First Maruzen Oil Company Art Encouragement Award; Masanari Murai and Toshimitsu Imai receive merit awards at fifth Japan Contemporary Art Exhibition; Tetsugoro Yorozu exhibition held at Kanagawa Prefectural Museum of Modern Art; Japan Cultural Hall in Rome (designed by Isoya Yoshida) completed; Junzo Sakata designs Kure City Office, Hiroshima Prefecture; Kenji Imai designs Twenty-six Japanese Martyrs Memorial; Kunio Maekawa designs National Diet Library; Kenzo Tange designs Nichinan Cultural Center, Miyazaki Prefecture; Masato Otaka designs Kataoka Agricultural Cooperative, Tochigi Prefecture.

Salon de Mai Japan Exhibition, Block Prints of Joan Miró exhibition, "Picasso's *Guernica*" exhibition, One Hundred and Two American Artists of Today exhibition, and Sculpture of Lynn Chadwick and Kenneth Armitage exhibition held in Tokyo; Auguste Rodin's *Balzac* presented to National Museum of Western Art by Rodin Museum, Paris.

1963. Asahi Shimbun sponsors contest, including six foreign sculptors, at World Modern Sculpture Japan Symposium held at Cape Manazuru, Kanagawa Prefecture; Seiji Shimizu wins *grand prix* at first Outdoor Sculpture Contest, Ube, Yamaguchi Prefecture; Toshinobu Onosato wins prize at seventh Japan International Art Exhibition (sponsored by Mainichi Shimbun); Hideo Ogiwara wins prize at Ljubljana International Block Print Biennale; Soichiro Tomioka wins prize at São Paulo Biennale; Uichi Shimizu wins prize at International Ceramics Exhibition, Washington, D.C.; Kunio Maekawa designs Okayama Prefectural Art Museum; National Museum of Modern Art, Kyoto, opens (director, Atsuo Imaizumi); Kiyonori Kikutake designs Izumo Grand Shrine Office; Kunio Maetake designs Kanagawa Youth Cultural Center; Kenzo Tange designs Totsuka Country Club, Kanagawa Prefecture.

Aristide Maillol exhibition, Egyptian Art Five Thousand Years Ago exhibition, Bernard Buffet exhibition, Rufino Tamayo exhibition, J. M. W. Turner exhibition, Marc Chagall exhibition, German Expressionists exhibition, and Sketches of Arshile Gorky exhibition held in Tokyo; Meiji Village created at Inuyama, Aichi Prefecture.

1964. Yomiuri Independents exhibition, held annually since 1949, discontinued; Postwar Japanese Art exhibition held at Kanagawa Prefectural Museum of Modern Art; Sixty-four Artists of Today exhibition held at Yokohama Citizens Gallery; Japanese artists participate for first time in ninth International Women's Art Club Exhibition at Musée National d'Art Moderne, Paris, with ten artists represented including Yoshie Nakada and Toshiko Maruki; Yoshio Domoto wins prize at Venice Biennale; GK Industrial Research Institute receives Kauffmann Foundation Research Award; Nagaoka Contemporary Art Museum, Niigata Prefecture, opens, and its first Museum Award goes to Shinjiro Okamoto; thirty-eight artists including Saburo Aso and Yoshio Mori withdraw from Free Art Association; Kenzo Tange designs National Indoor Stadium for Tokyo Olympics and receives IOC Award; Togo Murano designs Nissei Theater; Kimio Yokoyama designs Daiseki-ji Guest House, Shizuoka Prefecture; Kenzo Tange designs St. Mary's Cathedral; Antonin Raymond designs Nanzan University.

Special exhibition of Venus de Milo, Salvador Dali exhibition, Gustave Moreau exhibition, and Contemporary English Sculpture exhibition held in Tokyo; Jean-Paul Sartre rejects Nobel Prize for literature.

1965. Exhibition of works by Japanese artists residing in Europe and America held at National Museum of Modern Art; Nika-kai holds Fiftieth Anniversary Retrospective Commemorative Exhibition; War-Generation Painters exhibition held at National Museum of Modern Art; "Shiba Kokan (1747–1818) and His Times" exhibition held at Kanagawa Prefectural Museum of Modern Art; Footsteps of Inten (Japan Art Academy Exhibits) exhibition held at National Museum of Modern Art; fifteen artists including Yoshishige Saito and Masuo Ikeda participate in Contemporary Japanese Art exhibition in Zurich; Takanori Ogisu returns to Japan to hold one-man show; Kumi Sugai wins highest award in painting division at São Paulo Biennale; Shu Eguchi wins *grand prix* at first Contemporary Japanese Outdoor Sculpture Exhibition at Ube, Yamaguchi Prefecture; Kentaro Kimura wins highest award at eighth Japan International Art Exhibition; Norikazu Sawada wins highest award at tenth World New Photography Exhibition at The Hague and also wins 1966 Pulitzer Prize; Kenzo Tange ranks first in competition for city planning to restore Skopje, Yugoslavia, following 1963 earthquake; Tange also receives gold award from Royal Association of Architecture, U.K.

Tutankhamen exhibition, "Sixty Years of Fauvism" exhibition, "What is Man?" photographic exhibition, and Jasper Johns exhibition held in Tokyo; Bruno Munari holds one-man show in Japan; movement to protect the beauty of the ancient cities of Nara, Kyoto,

and Kamakura begins; Tomonaga Shin'ichiro awarded Nobel Prize for physics; first international op art exhibition held at Museum of Modern Art, New York; Japanese arts featured at Berlin Art Festival.

1966. Masuo Ikeda wins highest award in block-print division at Venice Biennale; Yukiko Katsura wins highest award at seventh Contemporary Japanese Art Exhibition, which included special exhibition "European and Japanese Impressionism and Its Environs"; Kumi Sugai receives 1965 Recommended Art Award; Morio Shinoda and Kunihiko Isshiki receive Kotaro Takamura Award in plastic-arts division; Kenzo Tange receives gold award from American Architects Association; New Generation of Contemporary Art exhibition held at National Museum of Modern Art; Kenzo Okada (1902–) exhibition, Ryusei Kishida (1891–1929) exhibition, and "From Space to Environment" exhibition held; Kanagawa Prefectural Museum of Modern Art Annex completed (designed by Junzo Sakakura), and in commemoration "One Hundred and Fifty Years of Modern Western-style Painting in Japan" exhibition held; Yoshio Tani-guchi designs Yamatane Art Museum and Idemitsu Art Gallery; Nagano Prefectural Art Museum opened; Ryokichi Mukai, Morio Shinoda, Chikara Hiroi, Jo Oda, Seiji Shimizu, and Yoshikuni Iida sculpt commemorative steles for six stations on Tokyu Den'en Toshi Line; Yukio Ota designs Kyoto International Conference Hall; Yoshinobu Ashiwara designs Sony Building; Japan Construction Metal Products Co. builds Palace-Side Building; Imperial Theatre and National Theatre of Japan inaugurated.

"Famous Seventeenth-Century European Paintings" exhibition, Joan Miró exhibition, Henri Rousseau exhibition, Auguste Rodin exhibition, Reader's Digest Famous Modern Western Paintings exhibition, Soviet National Museum of Fine Arts Famous Modern Paintings exhibition, Polish Poster exhibition, "Peace on Earth" international photographic exhibition, Henri Cartier-Bresson's "Moment of Truth" photographic exhibition, World Avant-garde Film Festival, and convention of Eastern and Western art specialists to discuss the mutual influence of Eastern and Western art (sponsored by UNESCO) held in Tokyo.

TITLES IN THE SERIES

Although the individual books in the series are designed as self-contained units, so that readers may choose subjects according to their personal interests, the series itself constitutes a full survey of Japanese art and will be of increasing reference value as it progresses. The following titles are listed in the same order, roughly chronological, as those of the original Japanese editions. Those marked with an asterisk (*) have already been published or will appear shortly. It is planned to complete the English-language series in 1976.

The "weathermark" identifies this book as a production of John Weatherhill, Inc., publishers of fine books on Asia and the Pacific. Supervising editor: Ralph Friedrich. Book design and typography: Meredith Weatherby. Layout of illustrations: Akito Miyamoto. Production supervision: Yutaka Shimoji. Composition: Kenkyusha Printing Co., Tokyo. Color-plate engraving and printing: Nissha Printing Co., Kyoto, and Hanshichi Photoprinting Co., Tokyo. Gravure-plate engraving and printing: Inshokan Printing Co., Tokyo. Monochrome letterpress platemaking and printing and text printing: Toyo Printing Co., Tokyo. Binding: Makoto Binderies, Tokyo. The typeface used is Monotype Baskerville, with hand-set Optima for display.